Compton Verney

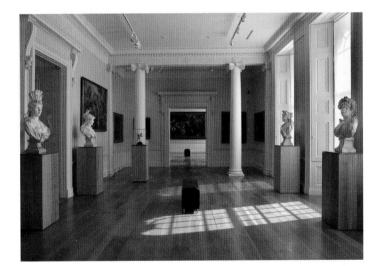

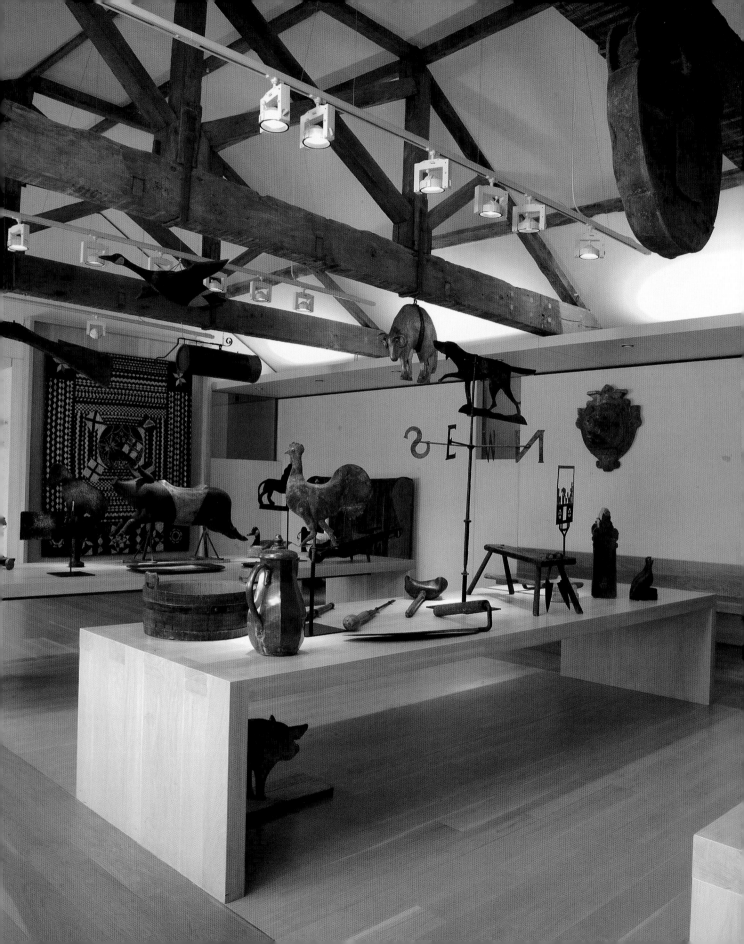

Compton Verney

SCALA

Compton
Verney

First published in 2010 by
Scala Publishers
Northburgh House
10 Northburgh Street
London EC1V 0AT
www.scalapublishers.com

ISBN-13: 978-1-85759-560-4

Project manager and copy-editor: Linda Schofield
Designer: Chrissie Charlton & Company
Printed and bound in China
10 9 8 7 6 5 4 3 2 1

Front cover: **Attributed to William Scrots**, *King Edward VI*, c.1550 (see p.81)
Back cover: **George Smart**, *Old Man and Donkey*, 1833 (see p.128)
Page 1: View of the Naples Gallery
Page 2: View of the Folk Art Gallery

Acknowledgements
We would like to thank the following for their help in researching the picture and object captions for this book: Ruth Burgon, Tony Isaacs, Nicola Jennings, Dave Jones, Diana Phillips, Peter Tolhurst, Jane Upson and Moira Walters. The captions were written by Susan Jenkins, John Leslie and Steven Parissien, with contributions from Verity Elson, Antonia Harrison, Annelise Hone, and Abi Pole.

Dimensions
Neapolitan, Northern European and British collections: dimensions given for all paintings are the size of the painting itself, unless otherwise stated. Folk Art and Marx–Lambert collections: dimensions given for paintings are the framed size, unless otherwise stated.

Contents

Fig.1

View of Compton Verney from the lake

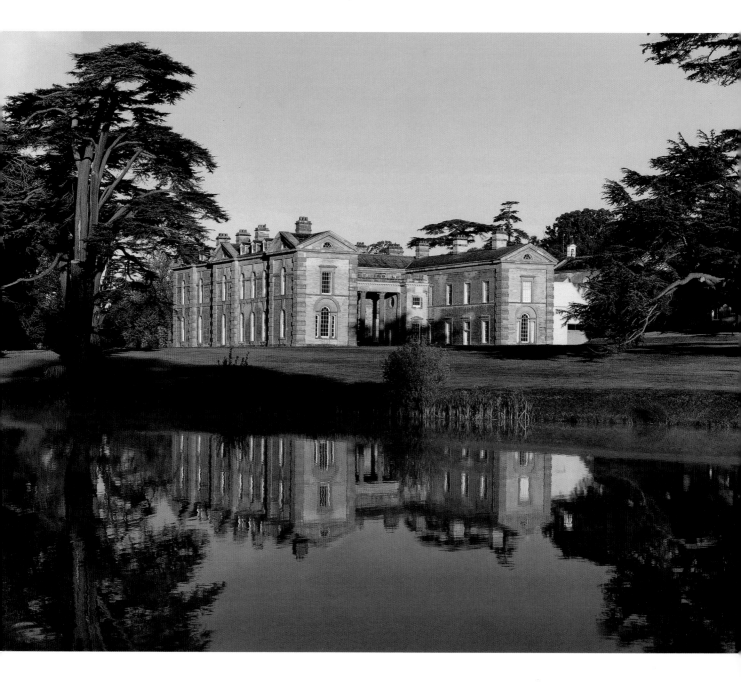

Foreword

There was a house on the Compton Verney site from around 1442. For almost 500 years – until 1921 – it was the home of the Verney family, the head of which was created Lord Willoughby de Broke in 1696. The house as we see it today, though, was originally built after 1711 by the Oxford master-mason John Townesend (1678–1742). During the 1760s, it was again extensively re-modelled and enlarged by Robert Adam (1728–92). (The Hall that we see today is largely Adam's work.) The park and the upper lake, together with the chapel, were created by the celebrated landscape gardener Lancelot 'Capability' Brown (1716–83) from 1769.

After 1921, when the Verney family sold the house and park, Compton Verney passed through a series of owners, and was even requisitioned as a military research establishment during World War II. Following the army's departure in 1945, however, the house was uninhabited for decades; thus by the 1980s, the house and park were suffering from serious neglect, while many parts of the estate, such as the walled garden, were sold off.

The 1990s saw Compton Verney's rescue and rejuvenation. The Peter Moores Foundation (PMF) had been set up by Sir Peter Moores in 1964 with a remit to assist opera, the visual arts and education. Sir Peter's aim was 'to get things done and open doors for people, but not to push them through'. He later observed that 'I feel passionately about demystifying the Arts and giving people the opportunity to make a choice. You cannot learn to like what you cannot easily come to know.'

In 1993, the mansion, 40 acres of parkland (later followed by another 80) and the middle lake were purchased by PMF and set up as a separate charitable trust: the Compton Verney House Trust (CVHT). The following year, the architectural practice Stanton Williams was appointed to plan the re-modelling of the house in order for it to serve as an art gallery, while Rodney Melville & Partners were made responsible for the historic conservation work at the site.

By 1990, the building had fallen into major disrepair. Lead had been stolen from the roof and ceilings had collapsed. Phase 1 of the restoration work involved the conversion of the country house into a state-of-the-art gallery, with repairs to the external envelope of the house and interiors plus the construction of the new wing to the north.

Phase 2 saw the completion of work on the principal rooms on the ground floor, retaining the remnants of historic internal fittings within a modern gallery setting; on the first floor, where originally there were bedrooms, few notable features remained by the 1990s; and in the attic, which was long ago used as servants' accommodation, there were merely large, vacant spaces. In 2004, the new gallery opened to the public.

The gallery's collections are diverse and fascinating, and comprise Neapolitan Baroque Paintings from the Golden Age 1600–1800; English Folk Art and the Marx–Lambert Collection; Archaic Chinese Bronzes; British Portraits; and Early Northern European Painting and Sculpture 1450–1650.

In an interview in 2004, Sir Peter explained that he 'encountered German art as a young man when I was sent to Hamburg to improve my German. I went to Cologne on several trips and I discovered the Wallraf-Richartz Museum … and it was full of beautiful works of art that I had never seen before.' In the 15 years of

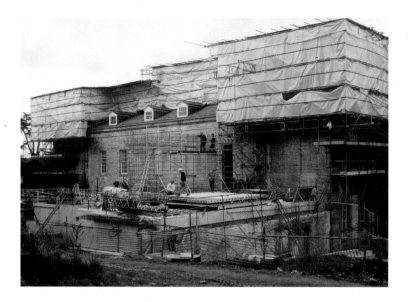

Fig.2
View of Compton Verney under restoration in 1997

focused acquisition in this area, Compton Verney has developed one of the best collections in the UK outside the Victoria and Albert Museum, London.

Sir Peter also regularly visited Naples when younger, finding much to admire in the way of life and developing a genuine love for the city and its visually powerful setting. Indeed, prior to the founding of Compton Verney, Sir Peter had developed his own small collection of paintings by Pietro Fabris (active 1754–1804). The opportunities at Compton Verney allowed for the development of a collection in this area, now one of the best in Europe outside the Capodimonte Museum, Naples.

Shortly after Compton Verney was purchased by PMF, the London dealer and collector Andras Kalman made an approach to Compton Verney with a view to selling his private collection of what was then known as the Crane Kalman Collection of English Naïve Art. The collection was acquired and is now believed to be the largest collection of English folk art in the UK. Inspired by this collection and its display, Enid Marx (1902–98) the textile and graphic designer, bequeathed her textiles, designs and her own collection of English folk art to Compton Verney in 1998.

Sir Peter's interest in Chinese art grew in the early 1980s following a visit to the Arthur M. Sackler Museum at Harvard University, where he found himself captivated by four or five particular bronzes. Supported by the Chinese scholar, Professor Dame Jessica Rawson, he began acquiring archaic Chinese bronzes for Compton Verney from 1993 onwards, a collection that now ranks in the top three in Europe, after the British Museum, London and the Guimet Museum, Paris. The vessels in the collection were produced over a period of more than 3000 years under many different Chinese rulers, and date from the early Shang dynasty (c.1500–1050BC) to the Qing Dynasty (1644–1911).

Sir Peter has also built up a small but intriguing collection of British portraits. The collection has now developed so that it focuses on key British sovereigns, and on celebrated British artists such as Sir Joshua Reynolds (1723–92) and Sir William Beechey (1753–1839).

Since Compton Verney's official opening in 2004, temporary exhibitions have also played a central role at the gallery. Echoing the values of the building and the setting, the programme has sought to combine the historic and the contemporary in a challenging, yet fresh and invigorating way. This has largely been achieved through the careful programming and pairing of exhibitions, so that resonances are often developed between exhibitions and the permanent collections.

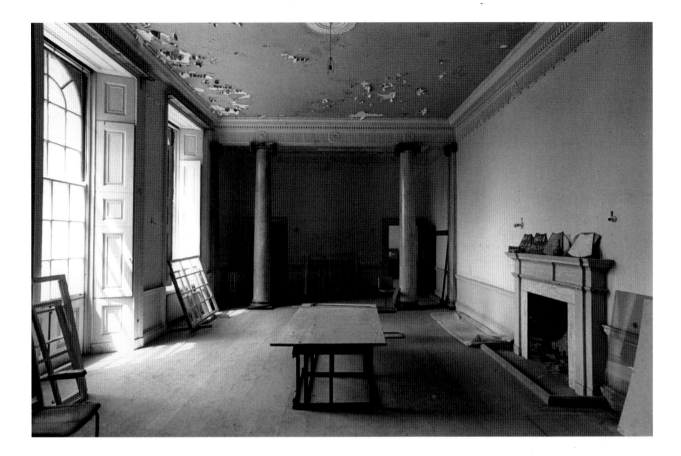

The founding of Compton Verney by Sir Peter Moores, through the Peter Moores Foundation, represents one of the major philanthropic gestures in the UK in recent years. The next decade will see Compton Verney further develop the opportunities within the parkland and the gallery. Not only will the collections and the exhibitions inside the house offer the quality of experience that has come to be expected at Compton Verney, but also the grounds themselves, with the restoration of the original 'Capability' Brown landscape, the ice house and the chapel, will all contribute to achieving Compton Verney's ambitions to share its passion for art in as accessible a way as possible.

Steven Parissien
Director, Compton Verney

Fig.3
The Salon at Compton Verney prior to restoration

Fig.1

The Prospect of Compton House

Engraving after a drawing by Wenceslaus Hollar *c*.1655,

published in William Dugdale's *The Antiquities of Warwickshire* in 1656

Courtesy of the Shakespeare Birthplace Trust

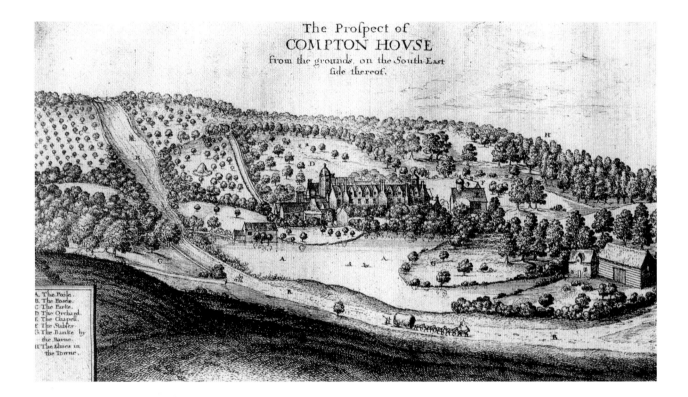

The History of the House and Grounds at Compton Verney

The first record of a settlement at Compton Verney was the late Saxon village of Compton. It had good communications being served by the Fosse Way, which ran north–south half a mile from the site and led from the Roman settlements of Cirencester to Leicester. By the time of the Domesday Book in 1086 (a survey carried out for the Norman king, William I (*c*.1027/28–1087), to record land ownership and values), the village was divided into two manors. The largest manor was originally held by the Count of Meulan; this was in turn inherited by the Earls of Warwick, who held it in the king's name. Some time before 1150, the smaller manor was granted to Robert Murdak and its village became known as Compton Murdak, passing by inheritance to the heirs of the Murdak family. In 1370, after 200 years of Murdak ownership, Sir Thomas Murdak surrendered the estate to Edward III's unscrupulous mistress, Alice Perrers (*c*.1340–1400/01).

In 1435, Compton Verney was acquired by the ruthless and ambitious Richard Verney (tenure 1435–90), with the assistance of his younger brother John Verney, Dean of Lichfield, and the powerful Richard Beauchamp, Earl of Warwick. The Verney family had begun acquiring lands in the area of Compton Murdak and the surrounding villages in the 1430s before purchasing the estate. By about 1500, the manor had become so closely associated with them that it began to be known as Compton Verney. According to antiquarian William Dugdale (1605–86), the Verney family also built a manor house there in about 1442. In 1656, Dugdale wrote in *The Antiquities of Warwickshire*: 'Richard Verney Esquire (afterward Knight) … built a great part of the House, as it now standeth, wherein, besides his own

Armes with matches, he then set up … towards the upper end of the Hall, the Armes of King Henry the Sixth.'[1] The house was further extended in the Tudor (1485–1603) and Stuart (1603–1714) periods, probably after the advantageous marriage of another Richard Verney (tenure 1574–1630) to Margaret, daughter of Sir Fulke Greville, Lord Brooke. Richard inherited her family estates and claims to the barony of Willoughby de Broke.

Very little is known about the Tudor and Stuart house at Compton Verney. A drawing by Wenceslaus Hollar (1607–77) of about 1655, published by William Dugdale (fig.1), shows a great hall, and a long south wing, with gabled dormer windows and chimneys, looking down to the lake. It had octagonal turrets at either end, kitchens to the left (south-west) and a chapel. The first surviving inventory of the house, which dates from the beginning of the Civil War in 1642 (the year in which the war's first great battle was fought at nearby Edgehill), describes a house of 30 rooms, including a hall, two parlours, 17 bedrooms, an armoury and study as well as servants' quarters and outbuildings, all furnished with velvet, tapestry and pictures to a total value of £900. A silk-and-wool embroidery depicting *Lucretia's Banquet*, and sold in 1913 to the Victoria and Albert Museum, London, may be one of the original pieces seen hanging in the Great Hall in *Country Life*'s photographs of the interiors, also of 1913.

Until the late Stuart era, the Verneys had not bothered to pursue their legitimate claim to the title of Baron Willoughby de Broke, an appellation that came through the female line. However, when Richard Verney inherited the estate from his great-nephew

William in 1683, he decided to exert his claim to the barony. In 1696, the House of Lords accepted the claim and Richard Verney became the 11th Baron Willoughby de Broke (tenure 1683–1711).

Richard Verney's son, George, 12th Baron Willoughby de Broke (tenure 1711–28) – a Fellow of New College, Oxford and subsequently Dean of Windsor – inherited the estate in 1711 and decided to rebuild the house and re-landscape the gardens. This was a period when medieval houses such as the Duke of Devonshire's Chatsworth House were being re-modelled in the classical style, and new country seats such as the Duke of Marlborough's Blenheim Palace in nearby Woodstock were being built. George commissioned an extensive reconstruction of the earlier house, while preserving much of the plan of the original building. Architectural historian Richard Hewlings has convincingly attributed this new design to the Oxford master-mason (and sometime Mayor of Oxford) John Townesend (1678–1742) and his son William, noting the elevations' similarity to John Townesend's work at nearby Adderbury House, Bruern Abbey, Hope House in Woodstock and Durham Quad at Trinity College, Oxford. It is therefore Townesend's elevations that we see today on all but the eastern side of the house, the façade of which Robert Adam (1728–92) later re-modelled.

A map of the site from 1736 (fig. 3) shows that the house was now a square block, with stables to the north. These still exist and were built by the Scottish architect James Gibbs (1682–1754) in about 1735. Gibbs was then out of favour with the London élite on account of his Italianate Baroque style and his suspiciously Tory connections, but was employed by the Duke of Shrewsbury at nearby Heythrop at the same time that he was designing the handsome Compton Verney stables. The latter featured his characteristic 'Gibbs surrounds' of rusticated quoins around the doors and windows.

A visitor, John Loveday of Caversham, described the house in 1735:

Just on the right of the road between Little Keinton [sic] and Wellsburn [sic] is the seat of the Hon. Mr Verney … It stands low and is built of Stone; the front is towards the Garden and has 11 Windows … Below there is an handsome Gallery or Dancing Room … The Gardens, with the room taken up by the house contain 20 Acres. The Gardens rise up an hill, and are well-contrived for Use and Convenience. There are Views down to a Pond; of these Ponds there are 4 in a string, which make a mile in length.[2]

The basic layout of Compton Verney in the 1730s can be reconstructed from the surviving evidence, which includes two inventories dating from this period. It was a courtyard house, entered from the east, through an archway with a cupola in the east wing. The main apartments were in the west and south wings, with the servants' quarters on the north side where the service buildings were. The west wing was dominated by the Great Hall, which probably occupied the same site as the original medieval Hall built in the 1440s. The Great Staircase (now lost) led up from the Hall to the main apartments above.

Although there is little surviving trace of the magnificent landscape laid out by George, 12th Baron, a plan of their layout can be seen on the estate map of 1736. This shows that the Baroque landscape was dominated by a chain of five ponds, one of which, marked 'new pool', was presumably created at this time. The avenue running east to west formed the main approach to the house, while formal gardens were planted immediately north and south of the house. South of the lake there was an area of plantations crossed by avenues, and there was an ornamental canal on the west lawn.

George had thus re-modelled the house and gardens at Compton Verney to create an estate that was suitable for a family with a new title. When both his sons died, his great-nephew, John Peyto Verney (tenure 1741–1816), became 14th Baron; to his great fortune, he also inherited the neighbouring estate of

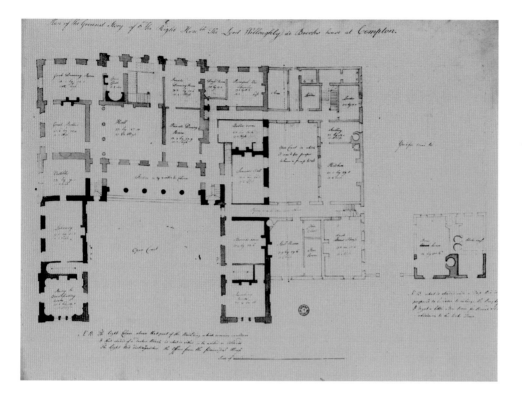

Fig.2
Robert Adam's plan of
the ground floor of the
house, showing proposed
new work in darker
shading, *c.*1760
Pen, pencil and ink
with colour washes
Courtesy of the Trustees
of Sir John Soane's
Museum

Chesterton, thus raising the family's income to a
handsome £4000 a year. This additional income, and
John's marriage in 1761 to the sister of future Prime
Minister Lord North (who lived at nearby Wroxton
Abbey in Oxfordshire), may have been what encouraged
the 14th Baron to improve the estate and completely
re-model the house once more. For at this time he
commissioned the prominent Scottish neoclassical
architect Robert Adam, by now the most fashionable
architect in the country, to make major alterations to
Compton Verney. (One of Adam's drawings for a new
east elevation, dated 2 September 1760, survives in
the Sir John Soane Museum, London.) Adam's proposed
re-modelling was much more extensive than anything
that had taken place before. His drawings of the
ground, first and attic storeys show what was to be
retained from the original building and what was to
be demolished (fig.2). Three of the four sides of the
original courtyard house (the east, north and south

wings) were to be torn down, and Adam proposed
the addition of a portico on the new east front and
the reconstruction of the north-eastern and south-
eastern wings – the execution of which gives the
house its present U-shape.

The building work was carried out from about
1762 to 1768, supervised by the Warwick architect
and mason, William Hiorne (*c.*1712–76), who was also
employed locally at Charlecote House and Stoneleigh
Abbey. The sandstone for the walls came from the
estate and the surrounding local quarries of Warwick,
Hornton, Gloucester and Painswick. The most important
changes attributable to Adam include the removal of
the Great Staircase on the west front and its replacement
by a saloon with pairs of columns; alterations to the
Great Hall, including the provision of a screen to the
south end, a tessellated marble floor (using British
marbles where possible) and large plaster frames to
house Antonio Zucchi's neoclassical *capricci* (see p.14);

and the creation of an attic storey. Adam also added a library and an octagonal study to the south wing, and adapted the brewhouse and bakery to the north of the house.

The floor plans of the house were published in the fifth volume of the survey of Britain's great houses, *Vitruvius Britannicus*, in 1771. The plans show certain differences from Adam's drawings, which suggests that some of the Baroque interiors had been left as they were. Adam was often responsible for the interior decoration as well as the architectural design of his buildings. However, at Compton Verney he designed the decoration of only a few rooms, including the Hall and the saloon; the remainder were decorated by local craftsmen using their own pattern-book designs. Adam's undated drawing for the decoration of the Hall in the Victoria and Albert Museum, London shows three plaster picture frames placed high on the walls that originally contained large landscape paintings with classical ruins. The landscapes were painted by the Venetian artist and favoured collaborator of Robert Adam, Antonio Pietro Francesco Zucchi (1726–95). After the house's sale by the Verney family in 1921, the paintings were sold by a subsequent owner, the 2nd Lord Manton, and only the frames remain.

Adam's new house is captured in the famous painting c.1766 of Compton Verney by the artist Johann Zoffany (1733–1810), now owned by the J. Paul Getty Museum, Los Angeles. The painting shows John, 14th Baron, and his family in the breakfast room on the ground floor at Compton Verney.

Although Adam's work on the mansion was completed in 1769, building work continued on the lesser buildings at Compton Verney until the 1780s and it was during this period that the grounds were re-landscaped. In 1769–70, the 'Green House' (which no longer survives) was constructed, and in 1771–72 the ice house and 'Cow House' were built. In 1769, Lancelot 'Capability' Brown (1716–83) was employed to lay out the grounds in keeping with the new taste for more naturalistic landscape. Brown eliminated all trace of the earlier formal gardens, including the canal on the west front and the avenues running east to west. He replaced them with grassland and trees, including cedars and over 2200 oak and ash saplings. Brown also turned the lakes into a single expanse of water by removing the dam between the Upper Long Pool and the Middle Pool to make way for his Upper Bridge. In 1772, he demolished the old church between the house and the lake, which had been described in the diary of the antiquarian George Vertue (1684–1756) in 1737. He replaced it with a new chapel, located on the slope to the north of the house, which was begun in 1776 and completed in 1780 for a total cost of £981.10s.4d. The late medieval Verney tomb and other memorials were moved to the new chapel, along with a mixture of English heraldic and German Renaissance glass panels that had decorated the old chapel. The tomb and wall-mounted monuments are still there, but the glass was unfortunately dispersed when it was sold by Lord Manton in 1931.

By the time of his death in 1816, John Peyto Verney, remembered as 'the good Lord Willoughby', had presided over the complete transformation of the house and grounds at Compton Verney. In the years following his demise, there were minor alterations to the building and estate. The solitary 16th Baron, Henry Peyto Verney (tenure 1820–52), commissioned engineer William Whitmore to extend the lower lake in about 1815 and architect Henry Hakewill to transform the saloon into a dining room in 1824. In 1848, an obelisk was erected over the old family vault near the lake. Around 1863 the 18th Baron, Henry (tenure 1862–1902), invited architect John Gibson (1817–92) to work on the site. Gibson was a leading High Victorian architect who specialised in the neoclassical style, and is now best known for his work for the National Provincial Bank – most notably his fine hall of 1865 (now the 'Gibson Hall') in Bishopsgate, London. At Compton Verney's Hall, Gibson added decoration to the ceiling, a splendid plaster frieze to the screen, and a new external doorway and superimposed frieze. He also added lodges at the main gates.

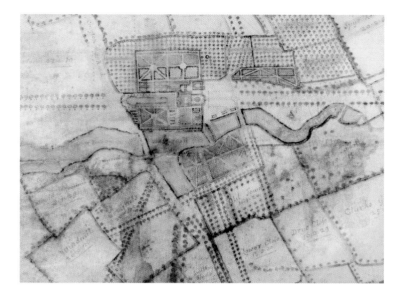

Fig.3
Compton Verney, the house and grounds, from an estate map by James Fish, 1736

The history of the estate over the last 150 years has been a chequered one. Compton Verney suffered in the agricultural depression of the 1870s and 1880s in common with other landed estates across the country, dependent as they were on agricultural rent for income. The house was, as a result, partly let out from 1887. The last Verney to live in the mansion was Richard Greville Verney, 19th Baron Willoughby de Broke (tenure 1902–21), whose nostalgic memoir, *The Passing Years* (London, 1924), offers a sentimental description of life in the house before he was obliged to sell it in 1921. Richard died two years later, in 1923.

During the next 70 years the estate changed hands a number of times. The new owner in 1921 was Joseph Watson (tenure 1921–29), a soap manufacturer and racehorse owner, who became Baron Manton of Compton Verney the following year, only a few months before he died. His son George Watson, the 2nd Baron (tenure 1929–33), regretably sold the medieval stained glass in the Capability Brown chapel (some of which is now in the possession of Warwick Museum and the Burrell Collection, Glasgow) and the large Zucchi canvases in the Hall, before selling the house itself in 1929 to Samuel Lamb (tenure 1933–58). The Lambs, in turn, moved out during World War II,

when Compton Verney was requisitioned by the army and the grounds were used as an experimental station for smokescreen camouflage.

The house was never lived in again. In 1958, it was acquired from the Lambs by Harry Ellard (tenure 1958–83), a property and nightclub owner, who occasionally authorised film companies to use the grounds. By the 1980s, Compton Verney had become semi-derelict.

Since 1993, the house has belonged to the Compton Verney House Trust, which has restored it to its present fine condition. The extensive building programme funded by the Trust has given the building a new life as an art gallery, enabling Compton Verney to open its doors to welcome visitors once again.

Susan Jenkins and Steven Parissien

Notes

1. Quote from William Dugdale, *The Antiquities of Warwickshire* (London, 1656), p.435; new edition by W. Thomas, ed., 2 volumes (London, 1730), vol.I, p.565

2. S. Markham, *John Loveday of Caversham* (Salisbury, 1984), p.190

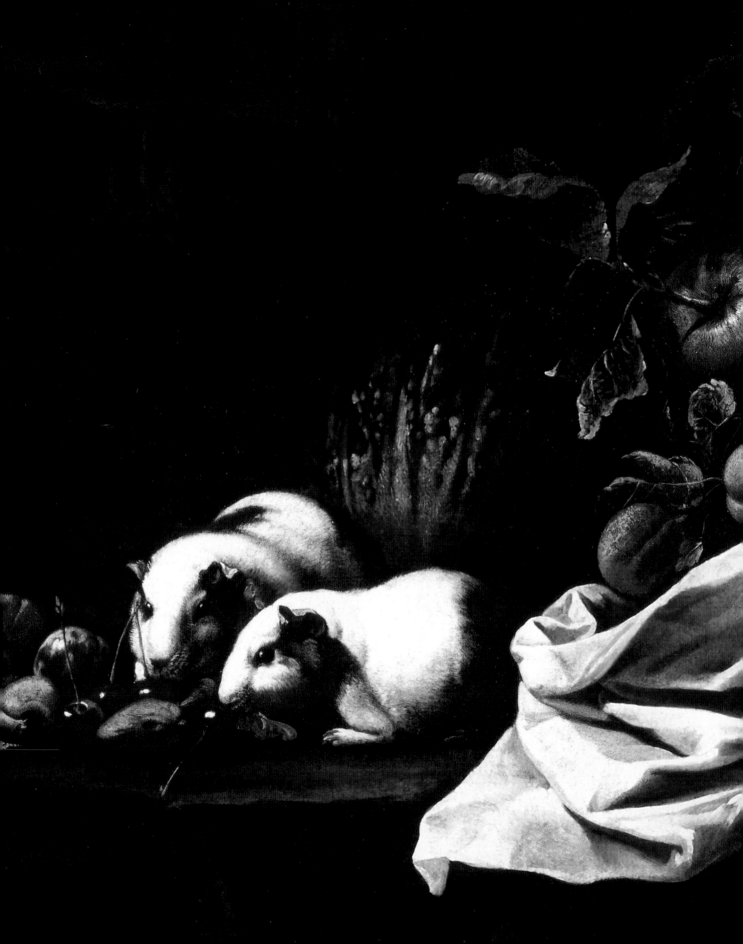

Naples

The Golden Age of Neapolitan Art, 1600–1800

Xavier Salomon

Naples in the 1600s and 1700s was – as today – a city of astounding visual contrasts. Ferocious sun and heat enlightened alleyways and narrow streets, where soaring buildings claustrophobically encircled human life and activities. The pungent smell of incense from thousands of churches competed with the overpowering stench of decayed meat and fish from the markets that crowded the streets of the city, and the cloying perfume of candles and flowers on the altars soon blended with the odour of rotten fruit and vegetables. Among the chaotic crowds, in between the noise of vendors and buyers, it would have been almost impossible to distinguish the loud prayers of women at road shrines and the swearing of the young and brash *lazzaroni*. The geographical site of the city was – and still is – one of unparalleled beauty: sprawling along the iridescent coast and the shimmering coves and bays of Castel dell'Ovo, Mergellina, Posillipo and Chiaia, the urban fabric rapidly grew along the steep hills up to San Martino and Castel Sant'Elmo, below the brooding shadow of Vesuvius. The architectural and natural spectacle of the city combined with its gritty and flamboyant social lifestyle justified the celebrated maxim 'see Naples and die'. The art that flourished in the city during its golden age is the manifestation of such disparities and needs to be measured against this background.

Capital of the kingdom of the Two Sicilies from 1266, Naples was by 1600 one of the largest cities in Europe, second only to Paris and with a population of more than 400,000 (almost three times that of Rome). From 1503 it was under Spanish rule and was governed by a series of Viceroys first and then by the Bourbon Kings from 1734. Rigid laws limited building within the city walls causing the construction of characteristically tall houses that crammed the city.

The economy of Naples flourished thanks to its mercantile power as one of Europe's main harbours, banking activities prospered among the internationally diverse communities that inhabited the city, and the university – one of the oldest in Italy – attracted a vibrant intellectual milieu. The outstanding wealth of Neapolitan aristocrats and merchants contrasted, however, with the abject poverty of the majority of the population, giving rise to a disparity that was evident and predictably described by visitors. This social inconsistency was often exacerbated by famine and built up to bloody uprisings, the most famous of which was Masaniello's (1622–47) revolt, which started on 7 July 1647 and, despite the death of its leader a few days later, lasted almost a year. The idyllic site of Naples was also repeatedly subject to natural disasters. Volcanic eruptions, earthquakes and epidemics – the plague above all – were recurrent events. The plague of 1656 was a particularly brutal one, killing more than half of the population and counting among its victims famous artists such as Massimo Stanzione (1585–1656), Bernardo Cavallino (1616–56) and Aniello Falcone (1607–56).

The artistic practice in the city mainly catered for the wealthy minority without, however, failing to remember the harsher reality that surrounded the noble palaces and prosperous monasteries and convents. Rulers were, of course, among the main patrons of the arts. The Spanish Viceroys in the seventeenth century – most famously the Counts of Benavente (1603–10) and Monterrey (1631–37), the Dukes of Osuña (1616–20), Alcala (1629–31) and Medinaceli (1695–1702), and the Marchese del Carpio (1683–87) – often assembled collections of paintings that at the

Fig.1
Luca Giordano (1634–1705)
The Triumph of Judith, 1704
Fresco
Certosa di San Martino, Naples, Italy
Archivio dell'Arte – Luciano Pedicini, Naples

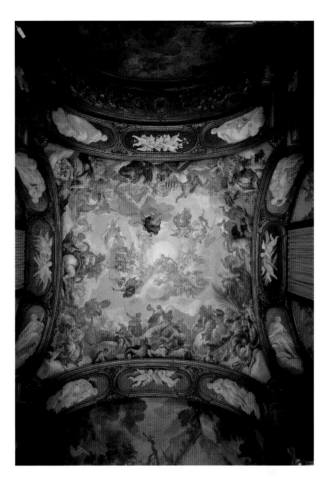

end of their terms of office were shipped back to their homeland. A century later, the Bourbon Kings' paintings and antiquities were destined for the vast royal palaces that were being built at Caserta and Portici. Ecclesiastical commissions were even more frequent in Naples. The concentration of churches, chapels and monastic institutions made it possible for artists to have a steady stream of commissions for the millions of altars and private oratories at which the population devoutly prayed. The Certosa di San Martino, overlooking the city from its hill, is one of such foundations, where the splendour and quality of the religious commissions can still be witnessed (fig.1). The Archbishop of Naples, Ascanio Filomarino (1583–1666, Archbishop from 1641), was one of the most prominent patrons and collectors in Naples in the seventeenth century. Foreigners were also instrumental in the flourishing of the arts in the city, the two most famous examples being the Flemish merchant Gaspar Roomer (1634–74) and the British envoy Sir William Hamilton (1730–1803), with his celebrated collection of pictures, ancient gems and vases displayed at his residence of Palazzo Sessa.

The founders of the Neapolitan school of painting were, in fact, foreigners. Caravaggio's (1571–1610) two sojourns in the city in 1606–07 and 1609–10 were to have a lasting and indelible effect on local artists. His altarpieces – the *Seven Works of Mercy* (fig.2) and the *Flagellation of Christ*, 1607–09 (Museo Nazionale Di Capodimonte, Naples) among them – with their powerfully theatrical compositions orchestrated around the dramatic effects of light and shade, shaped the stylistic choices of Neapolitan painters for the century to come. Caravaggio's artistic legacy was endorsed by the other leading artist in the city, José

de Ribera (1591–1652), known as 'Lo Spagnoletto', after his native soil. He arrived in Naples in 1616 and spent the rest of his life producing large and horrific scenes of martyrdoms and ecstasies, heavily stimulated by the social poverty that surrounded him in the city. Lord Byron (1788–1824) recorded the '… stories/ of martyrs awed, as Spagnoletto tainted/ his brush with all the blood of all the sainted' in the thirteenth canto of his *Don Juan* (1823). The typically violent Neapolitan approach to such sacred subjects was a reflection of the criminality that reigned outside the artists' workshops. A series of foreign artists – Annibale Carracci (1560–1609), Guido Reni (1575–1642), Domenichino (1581–1641) and Giovanni Lanfranco (1582–1647) – who came to Naples to work on prestigious commissions such as the Cappella del

Fig.2

Caravaggio, Michelangelo Merisi da (1571–1610)
The Seven Works of Mercy, 1607
Oil on canvas
Pio Monte della Misericordia, Naples, Italy/
The Bridgeman Art Library

of Caravaggio's and Van Dyck's paintings. Luca Giordano (1634–1705) and Francesco Solimena (1657–1747), with their extravagant compositions supported by the two artists' talent and speed (Giordano was nick-named *Luca fa presto* ('does it quickly')), prominently introduced a more international flavour in Neapolitan art by dipping their brushes in the new taste for Venetian sixteenth-century painting (especially Paolo Veronese (1528–88)) and Roman colleagues of the previous generation such as Pietro da Cortona (1596–1669). Giordano's travels promoted a specific view of Neapolitan elaborate and ostentatious painting through the courts of Rome, Florence (fig.3), Venice and Spain.

While the foremost artistic commissions centred on paintings with religious, historical or mythological subject matter, Neapolitan artists also particularly excelled in the genre of still life. Painters such as Luca Forte (*c.*1615–before 1670), Paolo Porpora (1617–75), Giovan Battista Ruoppolo (1629–93) and his nephew Giuseppe (d.1710) shaped a particular vision of nature with their pictures of flowers and fruit. Neapolitans adapted a genre deeply indebted to northern examples to their own particular principles. Flowers assume the consistency of luxurious textiles in decadent cascades that betray the passing of time in their almost withered state. Figs, *pizzutello* grapes, nectarines, peaches and melons are dramatically lit and become almost abstract pieces of marble, glossy and polished. The taste for opulence, colour and sumptuousness of materials is embodied in Neapolitan sculpture and goldsmith work. Cosimo Fanzago's (1591–1678) and Lorenzo Vaccaro's (1655–1706) gold, silver and marble creatures betray the same devotion to intricate forms, glistening surfaces and wide-ranging textures that is noticeable in other forms of Neapolitan art.

Tesoro in the Cathedral, were welcomed by local artists with intimidation, life-threatening letters and murder. When Domenichino died in the city, his wife was convinced that he had been poisoned by his artistic rivals.

The authority of Caravaggio and Ribera dominated the artistic scene for most of the following century. The next generation of painters was also powerfully influenced by Flemish artists through the works of Peter Paul Rubens (1577–1640) and Anthony van Dyck (1599–1641) some of which took the place of honour in Gaspar Roomer's collection. Bernardo Cavallino's art is the quintessential Neapolitan example of an artistic practice that, in its potent drama and lyrical delicacy, is the ideal outcome of an amalgamation

Fig.3
Luca Giordano (1634–1705)
View of the loggia with ceiling fresco depicting the Apotheosis of the Second Medici Dynasty, 1670–88
Palazzo Medici-Riccardi, Florence, Italy/The Bridgeman Art Library

After 1700, the tradition of the Grand Tour rapidly established Naples on the itinerary of foreign – mainly English – visitors (fig.4). For them, Naples was not only the city of gritty contradictions but also a romantic place of picturesque life, musical idylls and natural wonders. Vesuvius, together with the Phlegraean Fields and other sites around Naples, became the icon of this shift. The Italian poet Giacomo Leopardi (1798–1837) memorably portrayed the *formidabil monte sterminator* ('formidable assassin mount') while describing its sublime and desolate landscape in his poem *La Ginestra* (1836). Every tourist returned from Naples with an image of its eminent and ominous volcano. The staggering paintings of erupting Vesuvius by Pierre-Jacques Volaire (1729–*c*.1792), Pietro Fabris (active 1754–1804), Giovan Battista Lusieri (1755–1821) and Jakob Philip Hackert (1737–1807) were as popular as the inevitable visit to the volcano, often in the company of Sir William Hamilton, to witness, if fortunate enough, one of the spectacular eruptions. This was also a time of archaeological discoveries and the findings at Pompeii and Herculaneum excited tourists as much as the monumental ruins of the Greek temples of Paestum, immortalised by artists in views often destined for an international market.

Over more than 200 years, Neapolitan art developed and flourished in its golden age thanks to its close connections with the political and social circumstances in which it was embedded. The combination of archaic beauty, luxurious nature, brutal crime and scenic character that made Naples a popular destination was also the winning formula behind the creation of artworks that were immediately recognisable to a local and international audience for their intrinsic beauty, exoticism and sheer spectacle.

Fig.4
Pietro Fabris (active 1754–1804)
Concert party at the Neapolitan residence of Kenneth Mackenzie (1744–81), 1st Earl of Seaforth, May 1770
Oil on canvas
© National Gallery of Scotland, Edinburgh/
The Bridgeman Art Library

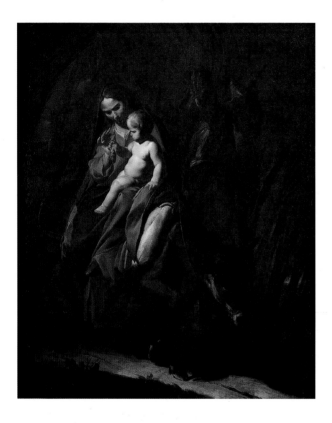

1

Bernardo Cavallino (1616–56)
The Flight into Egypt, c.1640–50
Oil on canvas, 76.8 x 63.5 cm

The flight into Egypt is briefly narrated by St Matthew in the second chapter of his gospel: warned by an angel that King Herod had ordered all infants in Bethlehem to be killed, Joseph 'rose and took the child and his mother by night, and departed into Egypt'. Following the biblical account, Bernardo Cavallino represents the scene at nightfall, in a dense wood. Mary sits on a tired donkey and appears to be handing some fruit to Jesus who is resting in her lap, while Joseph can just be made out in the background. The predominantly sombre tones of the painting emphasise the hasty and secret nature of the flight, and it is only a narrow shaft of light that illuminates the focal point of the painting, the melancholy group of the Mother and Child.

Little is known about Cavallino. Born in Naples, he was only 40 when he died. He painted around 80 works in total, yet won few public or large-scale commissions. He specialised in biblical and mythological scenes, but treated these in a very individual and distinctive way.

Cavallino's refined, naturalistic work does not derive from any single tradition. His early work shows the influence of Diego Velásquez (1599–1660), but in his 30s this gives way to the more painterly and less dramatic tradition of José de Ribera (1591–1652), Peter Paul Rubens (1577–1640) and Artemisia Gentileschi (1593–1652). Many of his compositions display an understanding of theatrical staging and frequently include emotionally charged exchanges between figures. The technique that he used of contrasting dark-toned sections with strongly-lit areas had been made popular by Caravaggio (1571–1610) in the 1590s, but remained fashionable in Cavallino's Naples well into the 1650s.

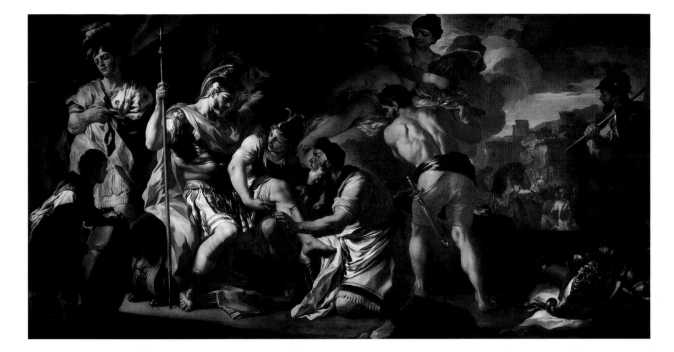

2

Francesco Solimena (1657–1747)
Venus with Iapyx Tending the Wounded Aeneas, c.1695
Oil on canvas, 210.8 x 365.8 cm

Francesco Solimena was the most important Neapolitan artist of his generation. This impressive canvas shows a scene from Virgil's epic poem, *The Aeneid*, in which Aeneas's mother, Venus (descending on a cloud), brings Iapyx, who tends him, the herbs he needs to heal the wound in Aeneas's leg. It is a magnificent example of the kind of heroic scene from history with which the public areas of Italian palaces were adorned in the Baroque era. Such works were often paired across a room, and this one was probably accompanied by a pendant of *Priam in the Tent of Achilles*, now lost. Sketches for both these canvases are also in the Compton Verney collection.

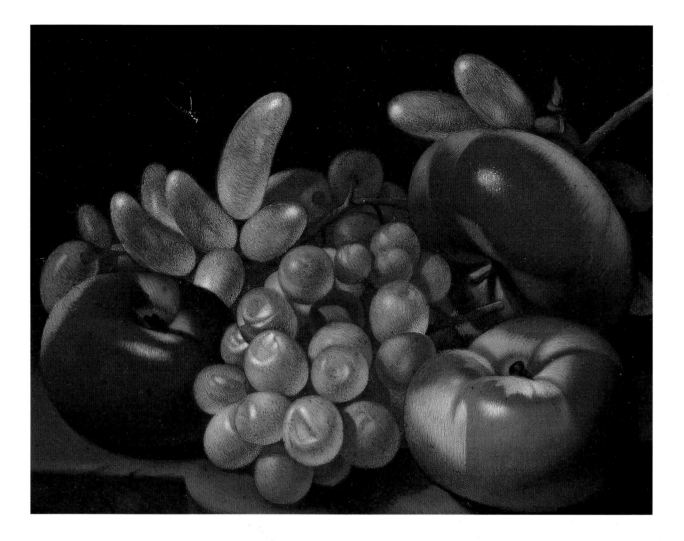

3

Luca Forte (*c*.1615–before 1670)
Still Life with Apples, Grapes and a Dragonfly, c.1650
Signed *l.f.*
Oil on copper, 15.6 x 20.6 cm

Luca Forte was one of the pioneers of still-life painting in Naples, especially of fruit. The still life emerged in Naples as a genre in its own right around 1600 and flourished from about the mid-1620s. Although Forte signed his works, he never dated them, and little is known about his life. It can only be assumed that he was active mainly in the period 1620–50.

This unusual still-life composition was painted on copper, a support favoured by artists for small-scale works. The smooth and uniform surface of copper allowed the use of a very fine brush to bring small details, such as the dragonfly hovering above the bunch of grapes in this work, into focus, and enabled the artist to high-light the polished surfaces of fruits, as here.

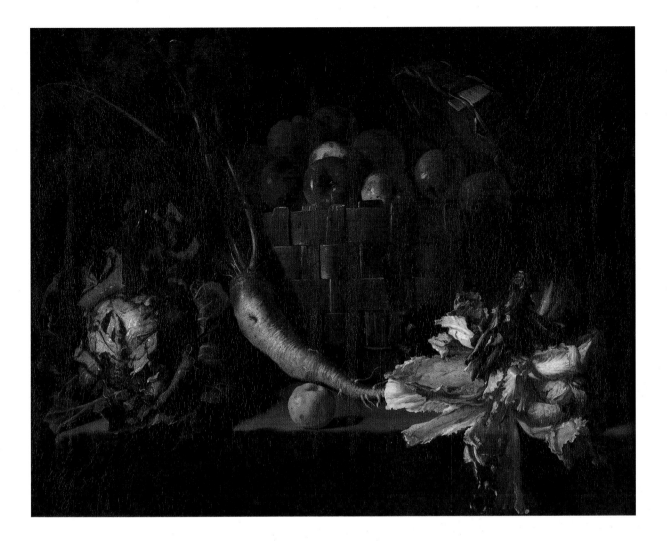

4

Giovan Battista Recco (*c.*1615–60)
*Still Life with Apples, Cabbage, Parsnip and Lettuce, c.*1650
Oil on canvas, 87 x 109.9 cm

Giovan Battista Recco was one of the most important Neapolitan still-life painters of the Baroque era. He may well have visited Spain early in his career, as he appears highly influenced by the Spanish still-life painters of the time (so much so that some of his paintings have in the past been mistakenly attributed to the young Velásquez), as well as by the Caravaggio-like tendency then prevalent in his native Naples, to use bright highlights in dark, moody contexts.

A device commonly used by Recco was the introduction of a stone ledge to support his still-life compositions. The strong light source from the left of the composition highlights the pitted surfaces and individual forms, giving a sense of both ripeness and decay.

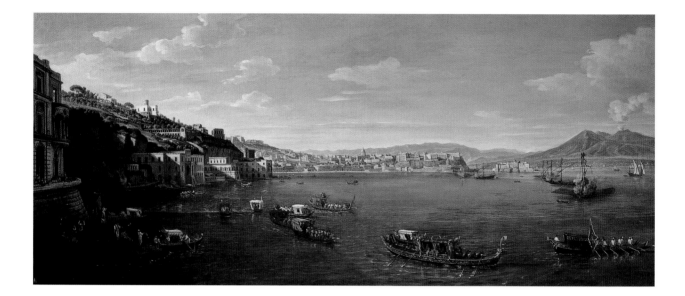

5

Gaspar van Wittel (known as Gaspare Vanvitelli)
(1652/3–1736)
Posillipo with the Palazzo Donn'Anna, c.1701
Oil on canvas, 72.7 x 170.3 cm

Gaspar van Wittel's stay in Naples between 1699 and 1702 was prompted by the invitation of the Spanish Viceroy, Don Luis de la Cerda, Duke of Medinaceli (1654–1711). The Duke was a great enthusiast of the artist's work and commissioned over 30 paintings from him.

Van Wittel (known as 'Vanvitelli' in Italy) specialised in the type of views known in Italian as *veduta esatta,* or accurate view, and indeed a large number of buildings on the Bay of Naples are identifiable in this painting. They include the Palazzo Donn'Anna, in the left foreground, which may have been occupied by the Viceroy. The gondolas crossing the bay are carrying aristocratic passengers, possibly the Viceroy's entourage. Resembling Venetian gondolas, they were probably introduced by the artist to add a note of contrasting colour to this predominantly light-blue composition. In 1701, Don Luis returned to Spain, taking his views of Naples with him as souvenirs. This painting remained in his family until it was acquired for Compton Verney in 2001.

6

Gabriele Ricciardelli (active 1740–80)
*Posillipo from the Riviera di Chiaia, c.*1764
Oil on canvas, 88.5 x 153 cm

Gabriele Ricciardelli, who was born in Naples, was one
of a number of painters of this period who specialised in
views of his native city. Such views were popular with
visitors to Naples who had come as part of their Grand
Tour; effectively, they provided the Grand Tourists with a
memento – and proof – of their visit to show their family
back at home.

The painting highlights the beauty of the Bay of
Naples and is animated with scenes of local life, including
dancing villagers and washerwomen at a trough.

7

Pietro Fabris (active 1754–1804)
The Temple of Hera at Paestum, c.1770
Oil on canvas, 56.6 x 90.5 cm

Pietro Fabris's origins remain mysterious. He called himself 'the English painter' and was described by his patron, Sir William Hamilton (1730–1803), the British envoy in Naples from 1764, as 'a native of Great Britain', but his surviving work is wholly Neapolitan in style and subject matter. This view of the Temple of Hera at Paestum near Salerno, south of Naples, reflects the revival of interest in the exceptionally well-preserved Greek temples there, which became popular tourist attractions from the 1750s. They were painted by Fabris on a number of occasions. In this work, he depicts the second and best preserved of the two temples at Paestum dedicated to Hera (Juno in Latin), which dates from about 450BC. Bathed in a warm sunset light, the ruin is romantically portrayed and evokes the classical past with nostalgia.

8

Pietro Fabris (active 1754–1804)
The Festival of the Madonna dell'Arco, Naples, 1777
Signed and dated lower left *Fabris p.1777*
Oil on canvas, 102.6 x 153.7 cm

Pietro Fabris painted this canvas for Sir William Hamilton. Now perhaps best known as the husband of Nelson's lover, Emma Hamilton (d.1815), Sir William was a great collector of paintings and classical antiquities. A list of his collection made in 1798 indicates that this painting hung in an anteroom to the gallery of his house in Naples, the Palazzo Sessa. It was paired with another work by Fabris,

showing a nocturnal banquet at Posillipo. The festival depicted was held on Easter Monday at the church of the Madonna dell'Arco (seen on the right). The sanctuary housed an image of the Madonna that was believed to have miraculously saved the shrine from destruction during the severe eruption of Vesuvius in 1631, which killed thousands.

Hamilton and Fabris collaborated on a number of projects, including the production by Fabris of plates for Hamilton's book about volcanic sites entitled *Campi Phlegraei*. Both men were interested in Neapolitan costumes and customs, which inspired this canvas.

9

Maker unknown (South Italian or Spanish)
A Pair of Console Tables, c.1750
Wood, gesso, pigment and gilding with green
granite tops, each 87.5 x 131 x 61 cm

Each of these elaborate console tables has a rare green
granite top. Their carved decoration is painted in gold,
white, green and pink, and is reminiscent of the delicate
porcelain produced for the court in Naples by the
Capodimonte porcelain factory. Across the front, in the
apron frieze, is the head of a lion holding two garlands of
roses, which wind their way around all four legs. Placed
across the centre of the leg stretchers is a two-headed
bird with outstretched wings, holding a flower in each

of its beaks. The raised head of one of the two-headed
birds is turned to the left, while the other is turned to the
right. This suggests that the tables were designed as a
pair, since when they are placed together the birds look
across at each other. The tables closely resemble decorative
furniture in the Spanish royal palace of El Pardo outside
Madrid and may have been made either in Naples or in
Madrid by a carver who knew the porcelain rooms created
in both cities by King Charles VII (1716–88) of Naples.
In 1759 Charles VII, whose own accession in 1734 had
effectively united the kingdoms of Spain and Naples-Sicily,
succeeded to the Spanish throne as Charles III, and
abdicated the Neapolitan throne in favour of his son,
Ferdinand IV (1751–1825).

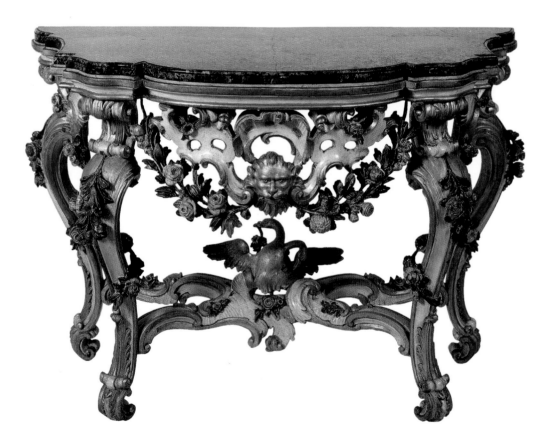

10

Maker unknown (South Italian)

Trapani Nativity Group, c.1700

Coral, silver gilt-copper and enamel, height 57 cm

The town of Trapani, on the island of Sicily in the kingdom of Naples, was famous for the production of such items, using the red Mediterranean coral in plentiful supply there in the Early Modern era. Very few of these delicate works survive.

The fashion for creating nativity scenes reached the height of its popularity in Naples and Sicily in the early 1700s. Coral was a particularly popular material for such works as it was taken to symbolise the blood of Christ.

11

Maker unknown (South Italian)

Trapani Casket, c.1700

Inlaid coral and mother-of-pearl, 20.2 x 56.5 x 44 cm

This Trapani casket would have contained letters or jewels. It is decorated with many different semi-precious stones, including jasper, agate, lapis lazuli and moss agate. The stones are held within gilt-brass mounts, which are delicately engraved to resemble leaves. Carved mother-of-pearl and red coral leaves are attached by fine wire all over the box and its edges are veneered with tortoiseshell. The casket has a red velvet interior and there is a secret compartment within the lid.

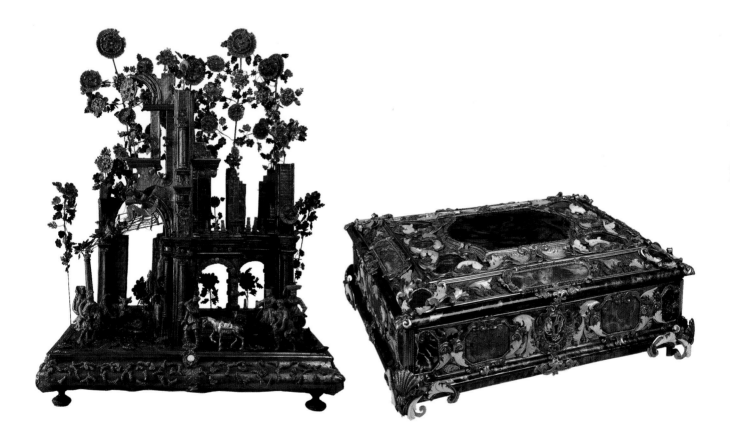

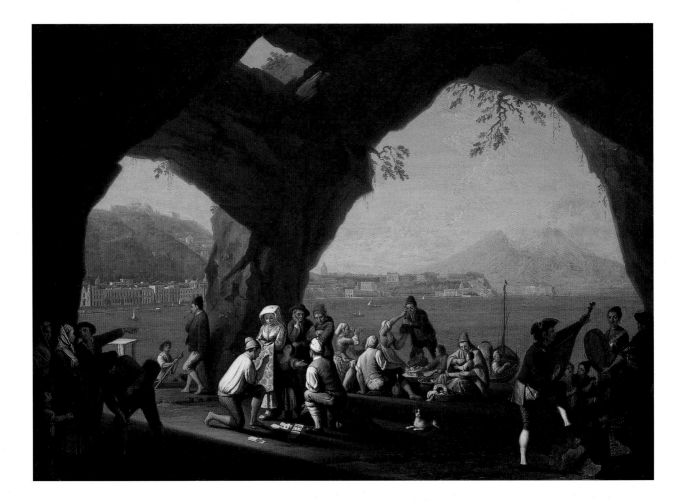

12

Pietro Fabris (active 1754–1804)
Naples from the West with Peasants Gaming, c.1760
Oil on canvas, 71.3 x 98.8 cm

Pietro Fabris was a prolific painter of scenes of Neapolitan peasant life. This work shows musicians, card-players and a wine-seller, all figures that regularly appear in his canvases. Glimpsed like a backdrop through the mouth of the cave is the Bay of Naples with Castel dell'Ovo and Mount Vesuvius in the distance. Fabris painted a number of different versions of this composition, one of which, in the Royal Collection, is signed and dated 1766. He often painted them in pairs or sets, and it is possible that this work originally had a pendant. Many of Fabris's views of Naples were engraved and some were personally hand-coloured by the artist to provide illustrations for Sir William Hamilton's study of volcanoes, the *Campi Phlegraei*.

13

Tommaso Ruiz (active *c*.1750)
*The Bay of Naples seen from Posillipo, c.*1760
Oil on copper, 32.2 x 78.5 cm

Tommaso Ruiz and his brother Juan both painted views of
Naples in a very similar style. This small scene – painted
on copper, allowing the artist to use a finer brush for
details – shows Mount Vesuvius in the background, and
is calculated to appeal to the tourist market.

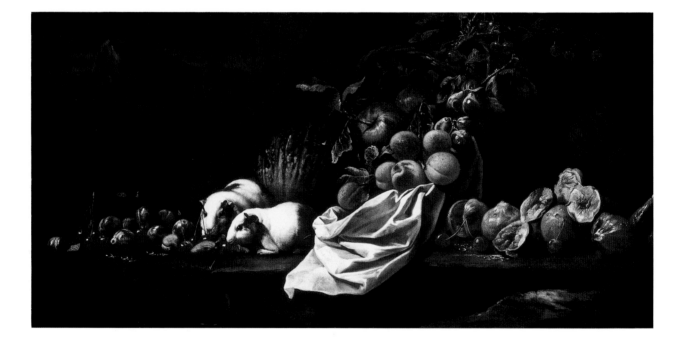

14
Giovan Battista Ruoppolo (1629–93)
Still Life with Figs, Cherries, Plums and Two Guinea Pigs,
*c.*1685
Oil on canvas, 57.8 x 131.7 cm

Giovan Battista Ruoppolo was one of the most sought-after painters of still life in Naples. His pictures were collected by the aristocracy and the mercantile élite, and this pair of fruit still lifes, with their long rectangular format, was probably designed to be hung over interior doors in a palazzo. The landscape background of the composition above, with two guinea pigs happily feeding on cherries and plums, is a typical Neapolitan invention. Mount Vesuvius, which overlooks the city, can just be made out on the left. In both compositions the fruits, displayed on a ledge, are subtly lit. In the painting opposite, a monkey peers out from behind half a watermelon.

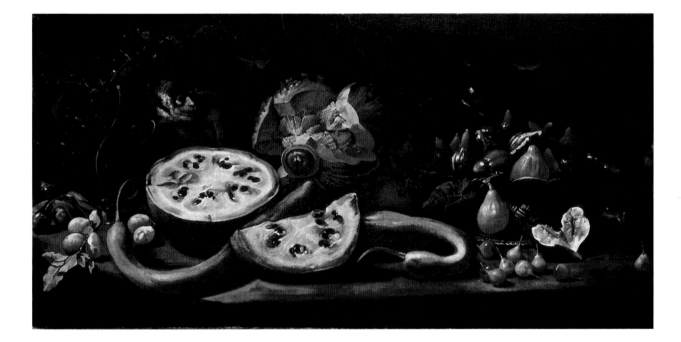

15

Giovan Battista Ruoppolo (1629–93)

Still Life with Watermelons, Plums, Cherries,
a Basket of Figs, Pears and a Monkey, c.1685

Oil on canvas, 57.8 x 131.7 cm

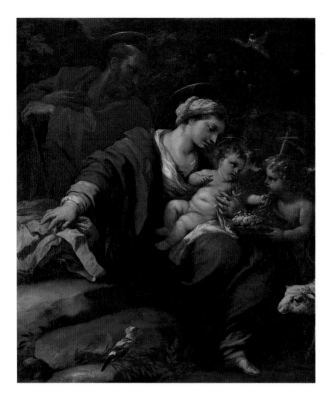

16

Luca Giordano (1634–1705)
The Holy Family with the Infant St John the Baptist, c.1675
Signed *Jordanus/.F*
Oil on canvas, 137.2 x 118.1 cm

Luca Giordano, also known as *Luca fa presto* ('does it quickly'), trained with the Spanish artist José de Ribera and became the most prolific and popular artist in Naples in his day.

Giordano was one of the most celebrated artists of the Neapolitan Baroque and his vast output embraced many secular as well as ecclesiastical pieces. His works move away from the Caravaggio tradition, espoused in Naples by Cavallino and others, of dark scenes highlighted by shards of shocking brilliance, to a more colourful and glowing idiom.

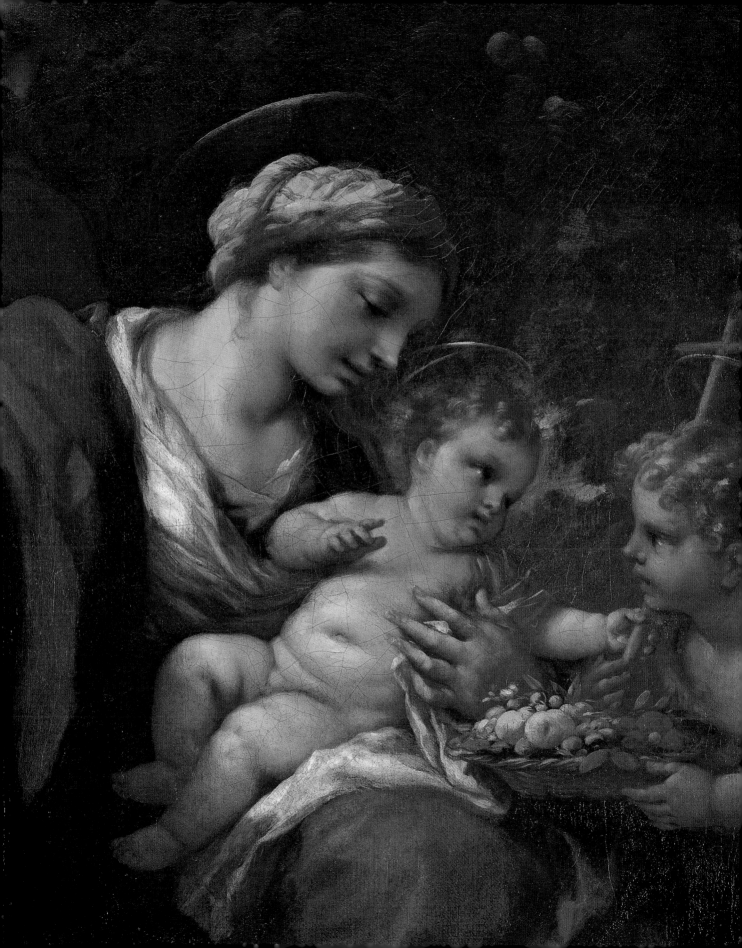

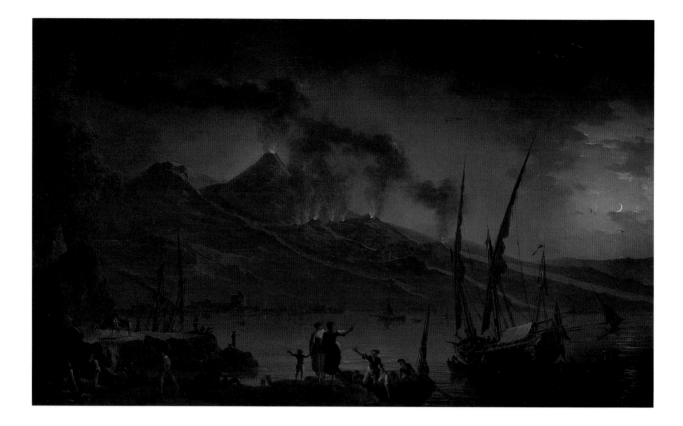

17

Charles-François Grenier de Lacroix

(known as Lacroix de Marseille) (1700–82)

Vesuvius Erupting, 1761

Signed and dated *Croix/1761*

Oil on canvas, 75 x 134.8 cm

Charles-François Grenier de Lacroix was born in Marseilles
– hence his popular name of 'Lacroix of Marseilles' – but
died in Berlin. He quickly established a reputation for
seascapes, gaining commissions from wealthy patrons;
this scene, however, concentrates not on the maritime
scenes for which he was renowned, but on the increasingly
familiar subject of Mount Vesuvius, the celebrated volcano
near the Bay of Naples. In Lacroix's lifetime, Vesuvius erupted
on five occasions: in 1707, 1737, 1760, 1767 and 1779.
The eruption of 1631 had killed 3000 people.

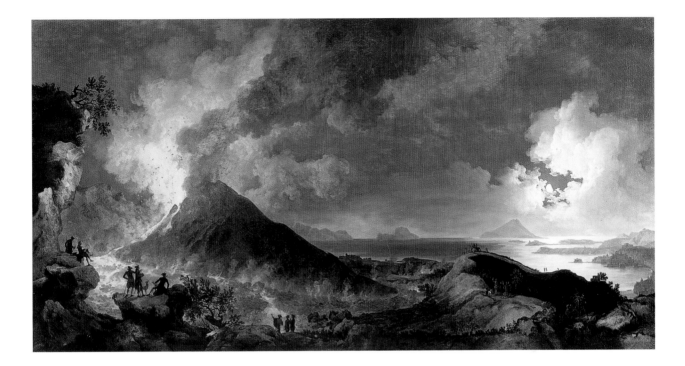

18
Pierre-Jacques Volaire (1729–*c*.1792)
An Eruption of Vesuvius by Moonlight, 1774
Signed, dated and inscribed *Eruption du Mont Vésuve …*
sur le lieu par le Che. Volaire 1774
Oil on canvas, 130 x 260 cm

Pierre-Jacques Volaire was a native of Toulon, in the south of France. There he met the painter Claude-Joseph Vernet (1714–89), when Vernet was working on his masterpieces, a series of views of the ports of France. Volaire remained Vernet's assistant for eight years before emigrating to Rome in 1764 and subsequently settling in Naples in 1769. He became famous for his numerous large paintings of Mount Vesuvius, which erupted several times in the 1770s – including 1774, the year of this painting. It was traditional (though dangerous) for tourists to visit the erupting volcano, and Volaire is documented as having conducted a visit to Vesuvius this very same year with an important client, Bergeret de Grandcourt.

Volaire's spectacular canvas was painted to hang as a pair with a view of the Solfatara, a volcanic crater near Pozzuoli.

19

Gennaro Basile (1722–82)
*Self-Portrait, c.*1755
Oil on canvas, 63.5 x 48.3 cm

Gennaro Basile was born in Naples, but found fame and
comparative fortune when he moved to the Austrian
Empire aged 30, in 1752. In 1766, he became court
painter to the Archbishop of Prague, and won many
ecclesiastical and secular commissions in the Austrian
territories east and north of Vienna. In 1780, he moved
to Brno in Moravia (in the present-day Czech Republic),
where he died two years later.

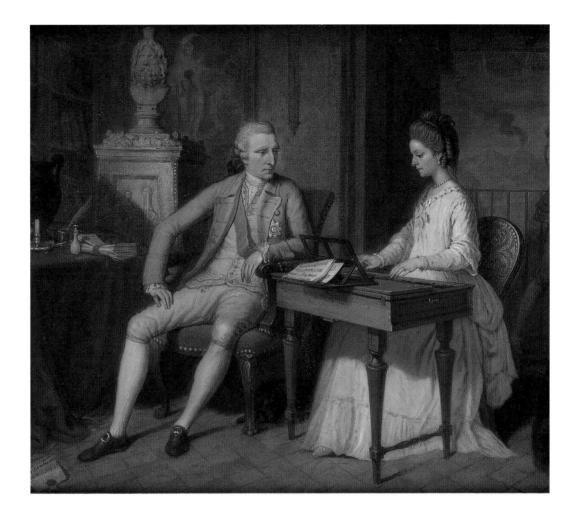

20
David Allan (1744–96)
Sir William and the first Lady Hamilton in their apartment in Naples, 1770
Oil on copper, 45 x 57 cm

Sir William Hamilton and his first wife, Catherine, are seen in the balcony room of their villa in Posillipo, near Naples. This portrait by the Scottish artist David Allan follows in the tradition of the conversation piece, capturing a private moment in a domestic setting. Hamilton sits listening to his wife playing the harpsichord, surrounded by many of his favourite objects, including his violin and a classical bust of Zeus. Vesuvius is depicted in the background as a reminder of Hamilton's many famous excursions to the crater's edge.

Allan's portraits are imbued with a sentimental realism that was greatly admired by Hamilton. Sir William himself was a celebrated antiquarian-diplomat who was instrumental in expanding Britons' understanding of the ancient world in the late Georgian era. Unfortunately, he is today better remembered for the infidelity of his second wife, Emma. They married in 1791 when Sir William was 60 and she was 26; by the end of the decade Emma was embroiled in a tumultuous and much-publicised affair with the British naval hero, Horatio Nelson (1758–1805).

21
Maker unknown
Cabinet, *c.*1600
Hardwood and ivory, with mother-of-pearl inlay,
height 52 cm

The exterior design of the cabinet (opposite), featuring a motif of foliage, birds and hunting figures in mother-of-pearl, shows the influence of German engravings from this period. The interior contains scenes relating to the Old Testament story of the Book of Esther, engraved into ivory. The drawers and doors inside are also faced with engraved ivory, a speciality of Neapolitan craftsmen such as Gennaro Piciato and Jacopo de Curtis.

The Book of Esther tells of the deliverance of the Jews of Persia from persecution. (Esther exposes the anti-Semitic intrigues of King Xerxes' Chief Minister, Haman, resulting in Haman's execution and the Jews' subsequent slaughter of their enemies.) Although the events of the Book of Esther, written in the second century BC, bear little resemblance to the actual history of Xerxes I's reign (r.485–465BC), the story does reveal an in-depth knowledge of Persian customs.

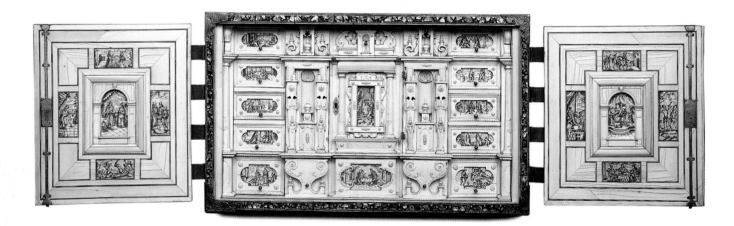

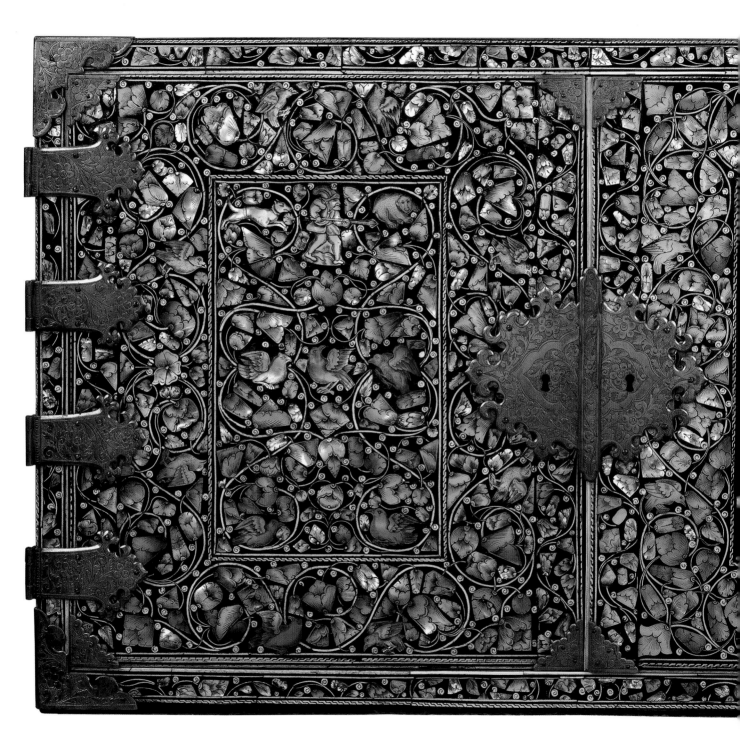

A New Realism:
Art in Renaissance Northern Europe
Jeremy Warren

Fig.1
Europe in the sixteenth century,
showing principal production centres
National Gallery, London

The term 'Northern European' refers to the vast swathe of Europe, running from Scandinavia in the north, through to the Low Countries (modern-day Holland and Belgium) and even England in the west, to Austria and Switzerland towards the south. But the core is Germany, which, during the period 1450–1650, was a cultural and linguistic entity not that different from the country we know today (fig.1). Politically it was, however, a very different story then, with the German-speaking areas of Europe divided into a myriad of larger and smaller states or autonomous towns and cities, each with its distinct and proudly maintained identity – a late sixteenth-century English traveller recorded the common German proverb 'the Merchants of Nuremberg, the Lords of Ulm, and the Citizens of Augsburg'.[1]

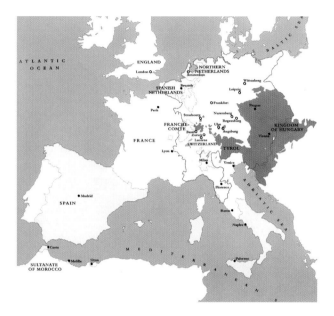

Most of Germany, as well as much of the Low Countries, owed allegiance, sometimes notional, to the Holy Roman Empire, the global superpower of the age. This vast and unwieldy agglomeration, which by 1550 had come to include Spain and Lombardy, was ruled over by the Habsburg emperors, among them Maximilian I (1459–1519) and Charles V (1500–58). The imperial armies of the Habsburgs, which were heavily engaged in the destructive wars that ravaged Italy during the first decades of the sixteenth century, relied heavily on German and Swiss soldiers, who were often hired as mercenaries. Known as *Landsknechte* (literally, if somewhat inappropriately, translatable as 'country lads'), these soldiers gloried in their fantastic costumes and their brutal reputations, enhanced by the general desolation and disease (including the terrifying syphilis, newly arrived from the Americas) that they left in their wake. German principalities

began ever more vigorously to assert their independence, a process driven by the growing religious fissures between Catholicism and Protestantism, which were to lead to the Reformation, the main flashpoint for Europe in the two centuries after Martin Luther (1483–1546). It was in Germany, with Luther's nailing of his 95 theses to the door of the castle church in Wittenberg in 1517, that the Reformation is popularly said to have begun. Protestantism spread like wildfire so that within a few years most German cities had opted either for the new religion or for the Catholic status quo, leading to further conflict, to which the Peace of Augsburg of 1555 put only a temporary halt.

Economic activity in almost all towns and cities in Northern Europe, including the organisation of artists and craftsmen, was based, as it was in Italy and

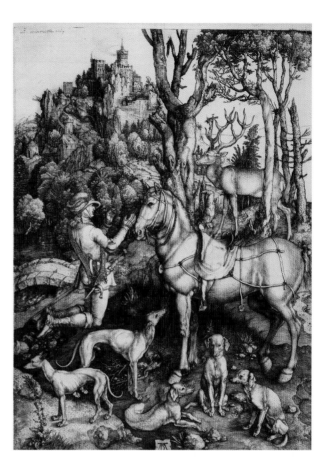

Fig.2
Albrecht Dürer (1471–1528)
*The Vision of St Eustace, c.*1501
Engraving
© The Trustees of the British Museum

elsewhere in Europe, on the medieval guild system. The guilds, often extremely powerful within their cities, served both to promote their particular trade and to protect the interests of the members. Each trade or craft, the practitioners of which were often concentrated in a single street or area of a town, would develop complex rules governing issues such as quality control and training. One fundamental concept for German craftsmen in particular was that of the journeyman, which required young apprentices to spend a period travelling and working for masters in other towns and cities. This encouraged greater cross-fertilisation of ideas and styles than might otherwise have been the case.

We have become accustomed to thinking of the Renaissance as an essentially Italian phenomenon. While it is true that during this period most of Europe, including the Northern European lands, looked to the Italian peninsula for leadership so far as fashion and good taste were concerned, the major contribution of Germany to the extraordinarily rapid development of European society during this period cannot be understated. As today, Germany was renowned for its advanced technology, which included the mining and working of metals, and the production of armour and stoneware ceramics. The most significant single technological development of the entire Renaissance – comparable in its impact to the birth of the Internet in our time – occurred in Mainz in 1455, when Johannes Gutenberg (*c.*1400–68) published his celebrated 42-line Bible, the first printed book in Europe. Germany made a huge contribution to the phenomenal growth in book publishing in Europe during this period and to the rapid spread of ideas that books enabled, as well

as to the equally astonishing development of the print as an art form. Prints, in the form of woodcuts and engravings, allowed the rapid dissemination of images throughout Europe, an opportunity eagerly seized on by some of the greatest northern artists of the time, among them Martin Schongauer (*c.*1440–91), whose tiny painting of *The Virgin and Child Crowned by Angels* (38) relates closely to engravings of the subject made by him during the 1470s. Schongauer, Albrecht Dürer (1471–1528) and Lucas van Leyden (1494–1533) all became famous well beyond Germany or the Netherlands, largely because of their prints. The Italian moralist Fra Sabba di Castiglione (1480?–1554) wrote, for example, of his pleasure one hot summer's day in escaping to a shady corner of his garden, where:

I set myself to looking at a print by Albrecht Dürer [fig.2], which is certainly divine and which had recently arrived from Germany. With delight and great pleasure I admired and considered the figures, animals, perspectives, houses, distant views and landscapes, and other marvellous depictions which would astonish Protogenes or Apelles.[2]

Sabba's description illuminates one crucial and distinctive aspect of Germanic art of the Renaissance that fascinated contemporaries as well as audiences today: northern artists' intense concern with naturalism and the recording of minute detail, whether it be the attention paid to the faces or costumes of sitters in portraits, or else to the interior or landscape settings of paintings and sculptured reliefs. When confronted with a picture such as Lucas Cranach the Elder's (1472–1553) *Lot and his Daughters* (27), you would, of course, have noticed and admired the carefully constructed figural composition in the foreground, but your eye would have been drawn also, as it is today, to the brilliantly detailed vision of the burning cities of Sodom and Gomorrah, which occupies almost the whole upper half of the picture. Likewise, the Bruges painter Ambrosius Benson (*c.*1495–1550) expended infinite care on the costume in his *Portrait of a Gentleman* (22), lingering on the fur-lined collar, the enamelled buttons and the array of rings he holds or wears on his fingers – thereby helping to emphasise the wealth and status of the sitter.

In German art, preoccupations with the real world could also, however, lead to an extreme and even exaggerated super-realism, ranging from the earthy to the grotesque. With works such as the *Crucifixion* from

Matthias Grünewald's (*c.*1470–1528) *Isenheim Altarpiece* of *c.*1515 (Unterlinden Museum, Colmar) or the allegories of artists such as Hans Baldung Grien (*c.*1480–1545) or Urs Graf (1485–after 1529), peopled with *Landsknechte*, witches and the always-present figure of Death (fig.3), German art could be truly horrific, even sadistic.

Netherlandish art of the time was generally more consciously elegant and idealising, showing greater awareness of developments in Italy and in part reflecting the very active trading links between the Low Countries and Italy at this time and the cultural interchanges thereby enabled. The contrast between the two tendencies can be seen very well if *Christ Taking Leave of His Mother* (39) by the Master of the Schwabach Altarpiece (active 1505–08), with its ungainly, even clumsy, main figures and, towards the bottom, its row of impossibly tiny donor portraits, is contrasted with the roughly contemporary *Lamentation* (32) by the Antwerp-based Master of Frankfurt (active *c.*1460–1520). Although in some respects, for example its fantastic and most un-Flemish landscape, it is no less stylised, the Netherlandish picture is pervaded by a quiet frozen elegance quite different from most German art of the time. In German painting and sculpture, Italian influence is much less evident and indeed until the 1530s seems almost to have been actively resisted by many artists and patrons who were determined to assert a distinctive German style. This included the very late survival of archaic stylistic elements derived from the International Gothic movement in Europe, including the use of much gilding and polychromy in paintings and sculptures. Implicit in the distinctive personality of

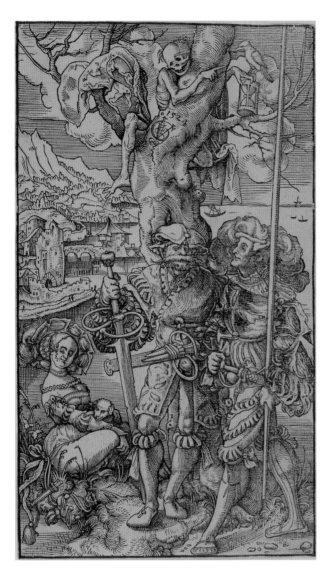

Fig.3
Urs Graf (c.1485–1529/1530)
Two Soldiers and a Woman with Death in a Tree, 1524
Woodcut

much Germanic art of the Early Renaissance is its highly emotive and subjective nature. Paintings and sculptures carried raw and direct experience to those witnessing them but, in the best of the art produced in Germany at this time, the artists themselves seem deeply aware of and preoccupied with the resonances of their subjects. It is perhaps no surprise that wood sculpture, in some respects the most original Germanic art form of this period, should be a process requiring the artist to hack, saw and file his raw material. Limewood, the commonest wood used for sculpture

in the southern parts of Germany, was regarded as holding magical religious properties, so that Tilman Riemenschneider (c.1460–1531), when carving his unidentified *A Female Saint* (30), was creating more than just a beautiful elegant figure.

It is difficult now to understand quite how all-pervasive religious imagery was before the Reformation. Production was enormous – the English alabaster workshops, based mainly in Nottingham, made literally thousands of examples of popular images such as the Resurrection or the head of St John the Baptist, generally working to standard patterns which became increasingly formulaic. Sculptures of this type or small religious paintings were generally owned by private individuals but would also have been acquired for the numerous monasteries and convents that were to be found in almost all towns and cities.

Within the towns themselves, religious images would have been everywhere: in streets and squares, in pubs and taverns in the form of prints and broadsheets and, above all, outside and inside the many churches. While all but the poorest churches would have been adorned with smaller altarpieces and free-standing statues, most churches would also have aspired to a grandiose statement for the main altarpiece. Some of the very greatest works of art produced in Germany and the Netherlands during this time were towering altarpieces with extraordinarily intricate and fantastic wooden architectural structures, which echoed but often outdid the buildings within which they were housed (fig.4). Within these wooden frames, which usually had moveable wings allowing the main scenes to be hidden or revealed at certain times in the church calendar, would be sculpted and

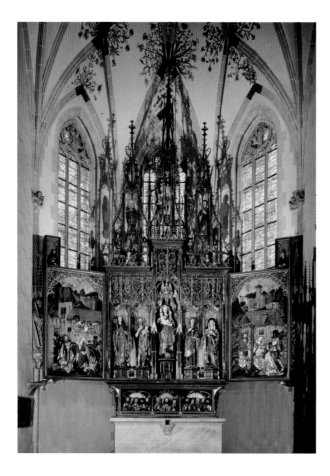

Fig.4

High altar with Mary on the crescent moon, John the Baptist,
John the Evangelist, Benedict and Scholastica
Sculptures by Gregor Erhardt, 1492/93 and altarpiece
by Joerg Syrlin
Blaubeuren (Baden-Wuerttemberg), monastery church
akg images / Erich Lessing

Franck (1499–c.1543) asked, '… who can describe
this buffoonery in all its detail? There is no misfortune,
need or disease that does not have a specific Saint for
it … for fire, flood, confinement, toothache, the falling
sickness and every evil',[3] while Jean Calvin (1509–64)
summed up the Protestant reformers' objection to
images:

> But the first vice, and as it were, beginning of the
> evil, was that when Christ ought to have been
> sought in his Word, sacraments and spiritual
> graces, the world, after its custom, delighted in
> his garments, vests and swaddling-clothes; and
> thus overlooking the principal matter, followed
> only its accessory.[4]

Much German sculpture was polychromed, painted in
a variety of colours and gilded in order to embellish
it and render it more realistic. Hans Thoman's (active
1519–50) half-length figures of *God the Father* and
God the Son (31) are excellent examples, retaining
much of their original polychromy and gilding. But
from the end of the fifteenth century there appears to
have been a distinct shift in some workshops, including
that of Riemenschneider, towards the production of
holzsichtig limewood sculpture in which the wood
was left unpainted. This was certainly partly done in
order to counter those reformers who criticised the
encouragement of superstition through the creation
of lifelike painted images. As the Reformation took
hold across the Germanic lands, its impact in terms of
iconoclasm (the ridiculing and destruction of images)
varied greatly. In some cities, for example Nuremberg,
Lutheranism was adopted along with a policy of

painted narrative scenes surrounded by large and
small standing figures. Often the Virgin and Child
would be at the centre of the altarpiece, surrounded
by saints and angels, sometimes carved in the round,
sometimes in half-relief. Those altarpieces that survive
in their original settings make an extraordinarily
impressive impact today, but to people living at the
time their awareness of the power of the Church and
organised religion embodied in these great altarpieces
would have been stronger still.

Throughout Europe in this period, the Catholic
church actively encouraged people of all classes to
regard images as, in some sense, real embodiments of
the saints and prophets they depicted. The misuse of
images and superstitious reliance on them were principal
targets of the early religious reformers. Sebastian

relative tolerance towards the display of images, whereas in Ulm in 1531 almost all religious works were removed from the cathedral and churches, though in an orderly manner. In other towns, iconoclasm was much cruder and more violent, with the wholesale ransacking of churches and destruction of paintings, sculpture, reliquaries and other precious objects. Ironically, the superstitious fervour with which images had previously been adored was transferred to their humiliation and destruction, with statues being hacked or burned, some placed into stocks or hung and mutilated like common criminals, and others mocked by being taken to bathhouses and taverns where beer would be forced onto them. Following the destruction in Basel in February 1529, Erasmus (c.1466–1536) tartly observed in a letter to a correspondent that he was 'greatly surprised that the images performed no miracle to save themselves; formerly the saints worked frequent prodigies for much smaller offences'.[5]

When they were not destroyed outright, altarpieces were often dismantled into their component pieces and then dispersed, beginning new lives as individual works of art. Further periods of instability, notably during Napoleon's occupation of most of Continental Europe after 1798, have since led to the breaking up and dispersal of many more altarpieces and ensembles. As a result, most collections of early Northern European art, including that at Compton Verney, consist principally of sculptures and paintings that are essentially fragments, surviving from what would once have been larger and more complex structures. This makes it difficult for the modern visitor to such collections to understand the narrative and structural relationships between a surviving fragment and its other elements, as well as the context within which such art was produced. However, it does allow us to appreciate individual paintings and sculpture as works of art in their own right and, through close observation, to realise that the best Germanic art deserves to be more widely appreciated for its power, its individualism and its often strange and surprising beauty. Thus, in studying the large relief of *The Holy Kinship* (37), we gradually come to realise how the heavy stolid figures of the Virgin and her mother, St Anne, draw us in towards the central figure of St Joachim, where the crown of his head is, in an astonishingly bold invention, provocatively thrust out towards the viewer. But as we follow Joachim's bent-down head, our gaze is inevitably drawn towards the real core of the composition, the response of grandfather to infant grandson, as tender a moment as any within the collections at Compton Verney.

Notes
1. William Smith, cited in John Hale, *The Civilization of Europe in the Renaissance* (London, 1993), p.60
2. Sabba di Castiglione, *I ricordi*, Venice, 1560, ricordo no.118, cited in Dora Thornton, *The Scholar in his Study. Ownership and Experience in Renaissance Italy* (New Haven/London, 1997), p.111
3. Sebastian Franck, *Weltbuch*, Augsburg, 1534, cited in Michael Baxandall, *The Limewood Sculptors of Renaissance Germany* (New Haven/London, 1980), p.55
4. Jean Calvin, *Inventory of Relics*, 1543, cited in Jeffrey Chipps Smith, *German Sculpture of the Later Renaissance c.1520–1580. Art in an Age of Uncertainty* (Princeton, 1994), p.34
5. Chipps Smith (1994), p.35

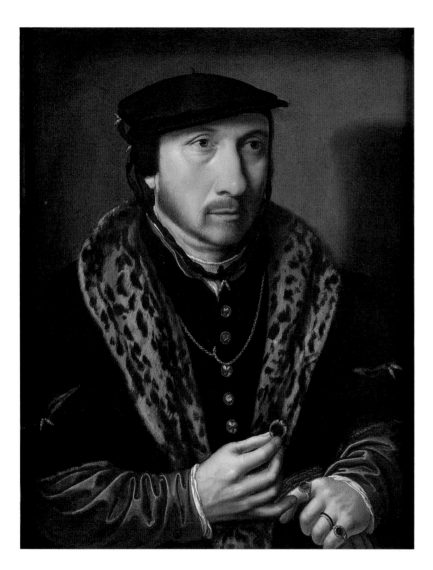

22

Ambrosius Benson (*c*.1495–1550)
Portrait of a Gentleman, *c*.1530
Oil on panel, 37.6 x 29.8 cm

Ambrosius Benson came from Milan but moved to Flanders (in present-day Belgium) and became a master of both the Bruges and Brussels guilds of painters in 1519 – at a time when these cities were governed by the Spanish Habsburgs. He is recorded as working there in the studio of the famous painter Gerard David (*c*.1460–1523), but quarrelled with him and later became a successful master in his own right.

Benson concentrated on producing religious paintings and very few portraits by him survive. The fine quality of this portrait of an unknown man shows the subtlety of his technique. The sitter's dress is depicted in great detail, from the fur lining of his cloak adorned with enamel buttons, to the gold pins on his hat and sleeves. The sitter may have been a jeweller or goldsmith on account of the quantity of fine jewellery that he wears and the ring that he displays prominently in his right hand.

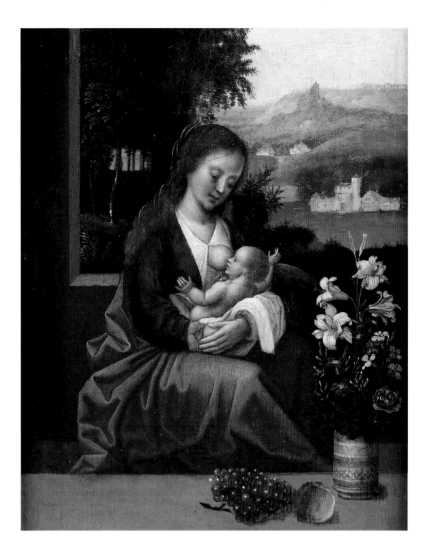

23
Ambrosius Benson (*c.*1495–1550)
The Virgin and Child, *c.*1520
Oil on panel, 21.3 x 16.2 cm

This small devotional panel portrays an intimate scene, the Virgin and Child before a window, which looks out on a naturalistic northern landscape. Its composition is similar to many painted by Gerard David, but Ambrosius Benson's work has a warmer palette and more rounded figures.

Mary had become increasingly important in the later Middle Ages. She came to represent an accessible figure to whom the faithful could appeal and acted as an intermediary between God and man. Netherlandish artists often used flowers as symbols and here the flowers in the majolica vase refer to the Virgin's role in redeeming Christ: the lilies indicate her purity; carnations were said to grow where her tears for Christ fell; and the irises symbolise the sword which pierced her heart as she experienced her son's rejection. Christ's outstretched arms also prefigure his death and the Eucharist is invoked by the bread and grapes.

24

Barthel Bruyn (1493–1555)
Portrait of Gerhard von Westerburg, 1524/38
Inscribed *1524/38*
Oil on panel, 62.3 x 52.4 cm

Barthel, or Bartholomäus, Bruyn was the leading portrait
painter in the Electorate of Cologne during the Early
Reformation and founded a lasting school of portraiture.
His depictions were honest and direct, while also respectful;
he focused on faces and hands rather than drapery, and
fashioned the former with meticulous care. Active in civic
affairs, he knew many of his sitters socially.

This is one of Bruyn's most important pictures, but
the sitter has only been correctly identified in recent years.
Gerhard von Westerburg (1486–c.1539) was a leading
Cologne lawyer and a keen supporter of the Reformation.
He appears to have commissioned this portrait to com-
memorate his marriage of 1523 to Gertraude von Leutz.
A portrait of his wife by Bruyn survives in the Kröller-
Müller Museum, in Otterloo.

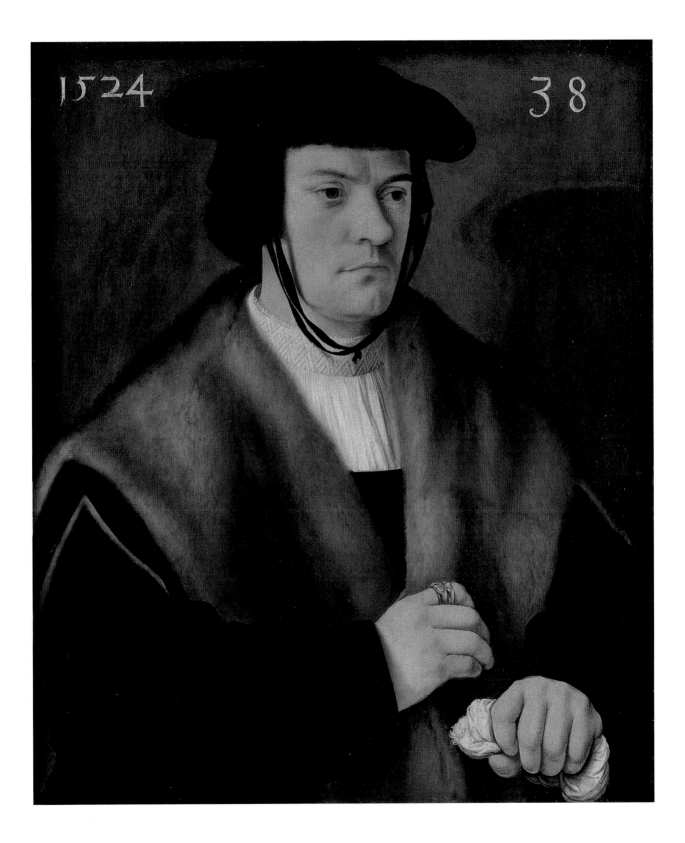

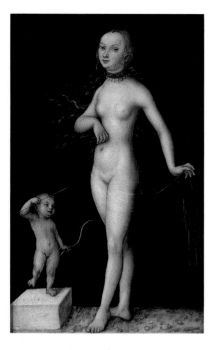

25

Lucas Cranach the Elder (1472–1553)
Venus and Cupid, c.1525
Oil on beechwood panel, 39 x 26 cm

By 1508, Bavarian-born Lucas Cranach the Elder had become court painter of the Electors of Saxony. In that year, Duke Frederick of Saxony (1463–1525) granted him a coat-of-arms, which incorporated a winged serpent, a symbol that he subsequently used as his personal signature and which can be seen in this painting on the plinth between Cupid's feet. In the 1520s, Cranach became a personal friend of Martin Luther (1483–1546) and many of his woodcuts were designed to promote the Protestant cause – which was also espoused by his ducal patrons.

The female nude was a theme that Cranach first explored in about 1509 and to which he returned with increasing frequency from the 1520s. Cranach depicts a nude Venus with her son Cupid – a subject that he painted many times in various formats, the most popular being *Venus and Cupid the Honey Thief*, a speciality of the Cranach workshop that appeared in at least 22 versions.

The earliest known *Venus and Cupid* is the life-size 1509 version now in the Hermitage Museum in St Petersburg. The Compton Verney painting is probably the earliest of Cranach's small panels of this subject.

The contemporary market for these nudes was found in private clients, such as the Dukes of Saxony at their court at Wittenberg, for whom the intrigue of the paintings lay in their subtle eroticism coupled with their moral undertones about the dangers of male lust. Here Venus fixes the viewer with a playful gaze. She wears only a jewelled necklace, but examination by infrared has shown that she was originally painted wearing a large crimson hat, now covered by the brown curtain behind her head. The dark background serves to emphasise the outlines of the two figures. Venus's transparent veil accentuates rather than conceals her naked body, adding to the coquettish atmosphere.

Cranach's workshop was the largest producer of female nudes in Northern Europe. The set-up of his Wittenberg workshop allowed one subject to be reproduced indefinitely without the sacrifice of quality; no two paintings were the same and each was a fresh interpretation of the subject.

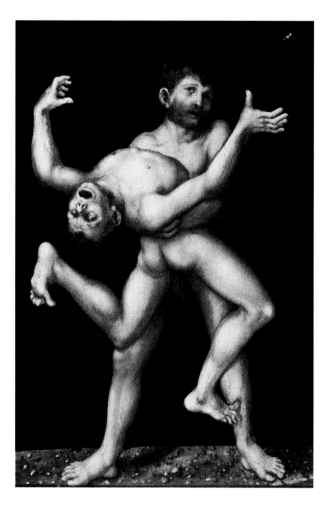

26

Lucas Cranach the Elder (1472–1553)
*Hercules and Antaeus, c.*1530
Oil on panel, 26.5 x 17.5 cm

Lucas Cranach the Elder adopted his surname from the town of his birth: Kronach, in present-day Bavaria. He founded a dynasty of Renaissance artists and his large and productive workshop proved a significant influence on his Northern European contemporaries. By the mid-1520s, Cranach was irrevocably associated with Martin Luther and the Reformation – in 1522 he had provided the woodcut illustrations for Luther's translation of the New Testament – and with Luther's powerful political patrons, the Dukes of Saxony. Cranach's ties with the ducal court were so strong that, following the defeat of Duke John Frederick of Saxony at the Battle of Mühlberg by the forces of Emperor Charles V (1500–58) in 1547, the artist followed his patron into exile in Bavaria and Austria, returning with him to Weimar in Saxony in 1552.

This painting depicts the eleventh task of the *Twelve Labours of Hercules*: his epic fight to the death with the giant Antaeus, son of Poseidon and Gaia – gods of the Sea and Earth. There are two known versions of this subject painted by Cranach. The other is in the Akademie der bildenden Künst in Vienna and depicts the fighters in a landscape setting. The neutral black background of the work at Compton Verney was a treatment often used by Cranach in his paintings of nude figures.

27

Lucas Cranach the Elder (1472–1553)
*Lot and his Daughters, c.*1530
Oil on panel, 55.9 x 39 cm

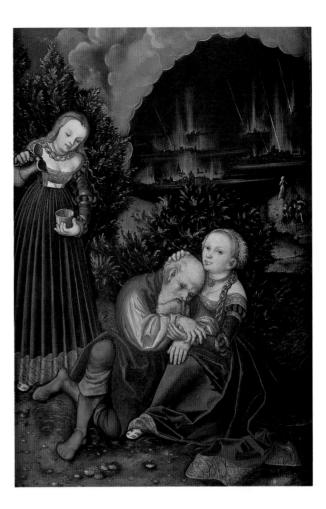

Lucas Cranach the Elder is known to have painted this famous Old Testament subject at least four times. The Book of Genesis (Chapter 19) tells of God's destruction of the sinful cities of Sodom and Gomorrah, which we can see burning in the background of this painting. In order to save the righteous, God sends two angels to lead Lot, one of the nephews of Abraham, and his family to safety. The men of Sodom attempt to rape the angels, and when Lot offers his virgin daughters instead, the Sodomites refuse them. The angels warn the family 'look not behind thee' but, as we can see in the middleground of the painting, Lot's wife looks back and consequently turns into a pillar of salt. In the foreground we see Lot and his daughters, who have fled to the safety of a cave. Fearing that they will never have children, and that their father will never have a male heir, Lot's daughters get Lot drunk on two consecutive nights and both become pregnant by him, later giving birth to sons. On the left of the painting, one of the daughters pours wine for her father, while the other seduces him with soft caresses.

Stories involving female domination over men were increasingly popular in the late Middle Ages. This theme was explored not only in the visual arts but also in literature, sermons, poems, songs and plays.

28

Lucas Cranach the Elder (1472–1553)
Portrait of Sigmund Kingsfelt, c.1530
Inscribed on panel *Sigmunt.Kingsfelt.Riter*
Oil on panel, 37.5 x 25.6 cm

Lucas Cranach the Elder did not work exclusively for the Lutheran court of the Electoral Dukes of Saxony in Wittenberg, but also for Catholic clients. This painting is a portrait of Sigmund Kingsfelt, who was a member of the knightly class. He is appropriately well-dressed and wears a simple but heavy gold chain. The details of his face are carefully drawn with a fine brush.

29

Hans Besser (active 1537–58)
*Portrait of Ludwig, Count Palatine,
aged ten*, 1549
Inscribed and dated
*Ludovicus. Com/Pal.Rheni.Dux Bavariae
Año./Dñi.1549.Aetatis.10*
Oil on paper on wood panel, 59.5 x 45 cm

When this portrait was painted in 1549,
the sitter, Prince Ludwig of the Palatinate
(1539–83), was living at the court of
Baden. In 1563, Ludwig became ruler
of the German principality of the Upper
Palatinate, and in 1576 succeeded to
the title of Elector Palatine, as Ludwig VI.
Unlike his father and brother, who were
Calvinists, Ludwig was Lutheran. Like
them, though, he was centrally involved
in the religious wars of the time between
the Protestant German princes and the
Catholic Habsburg emperors.

Hans Besser painted two similar
portraits of German princes of Baden –
Margrave Philibert (1536–69) and Margrave
Christopher II (1536–75) – in the same
year. Like them, Ludwig wears a black cap
decorated with gold petals, an oval hat
badge and a number of gold rings. In
addition, a hunting whistle, knife case and
knives hang from his belt.

Although he is known to have produced
murals and to have been considered for
an altarpiece commission, all of Besser's
surviving paintings are portraits dated
between 1538 and 1549. Critic Kurt
Löcher has singled out for praise 'the
freshness and magic of youth' conveyed
by the portraits of the three young
German princes mentioned above. This
portrait is the only work by the artist not
in a German museum.

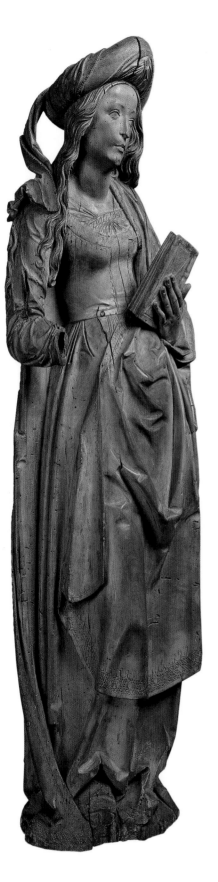

30

Tilman Riemenschneider (*c.*1460–1531)
A Female Saint, *c.*1515–20
Limewood, 106.7 x 33 x 16.8 cm

Tilman Riemenschneider was one of the most important sculptors in Germany in the early period of the Reformation. He settled in Würzburg in 1483, where he headed a workshop for nearly 45 years producing numerous altarpieces, statues and reliefs in materials ranging from alabaster to limewood.

This finely-carved sculpture of a female saint would originally have been part of an altarpiece, together with four other saints. The figure's posture suggests that she probably stood on the left of the central figure. The deep folds of the drapery add a sense of volume to the form, carved from a single piece of limewood and hollowed out at the back.

Such figures were often painted, but here the quality of the surface finish suggests that this was not the intention for this work. The saint originally held an object in her right hand – an 'attribute' – by which she would have been identified, but this has been lost, and she therefore remains anonymous.

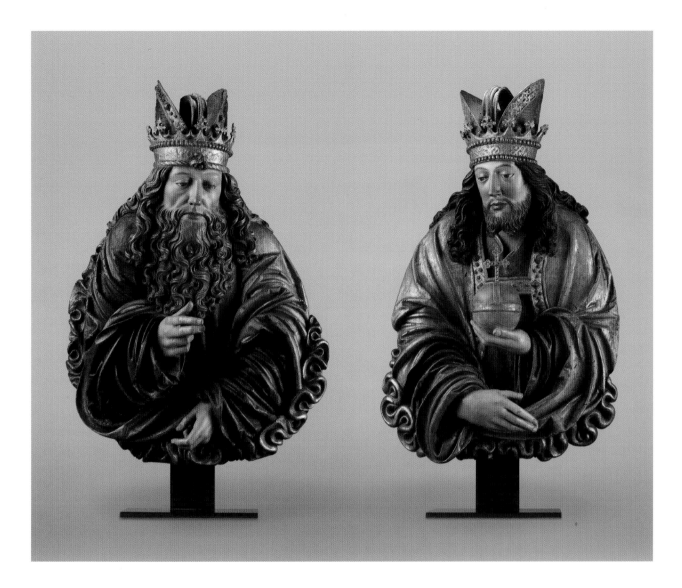

31

Hans Thoman (active 1519–50)
God the Father and *God the Son*, *c.*1520
Polychromed limewood with silvering and gilding,
heights 84 cm and 82 cm

These figures are part of a larger group, and would have
been positioned above pairs of saints and either side of
a crowned Virgin. (The saints are now in the German
National Museum in Nuremberg and the Virgin is in the
parish church of Oberliezheim, near Dillingen.)

They are certainly the finest surviving work by Hans
Thoman, a self-taught miller's son who worked largely
in his home town of Bavaria and the Habsburg lands to
the south and east. Tantalisingly little is known about
Thoman, although he has been recognised as one of the
leading figures of the German Renaissance and may well
have been the expert carver known to history only as the
Ottobeuren Master.

32

Workshop of the Master of Frankfurt
(active *c.*1460–1520)
*The Lamentation, c.*1500
Oil on panel, 115.3 x 84.8 cm

This painting, made from four wood panels, was produced in the workshop of an anonymous artist known as the Master of Frankfurt, a Flemish painter based in Antwerp. Although he probably never visited Frankfurt-am-Main, the artist's name derives from two commissions that he received from patrons in that city. Recent scholarship has, though, suggested that the name of the hitherto anonymous Master of Frankfurt was Hendrik van Wueluwe.

The painting depicts the scenes of mourning after Christ was taken down from the cross, the base of which can be seen on Mount Calvary in the background. Christ's body carried in a cloth is supported by Joseph of Arimathea, while Nicodemus is at his feet. Christ's mother, the Virgin Mary, is supported by St John the Evangelist. Behind her stand Mary, the mother of the apostles James and John; Mary, the mother of four other apostles; and Mary Magdalene carrying the jar of ointment with which she anointed Christ's feet.

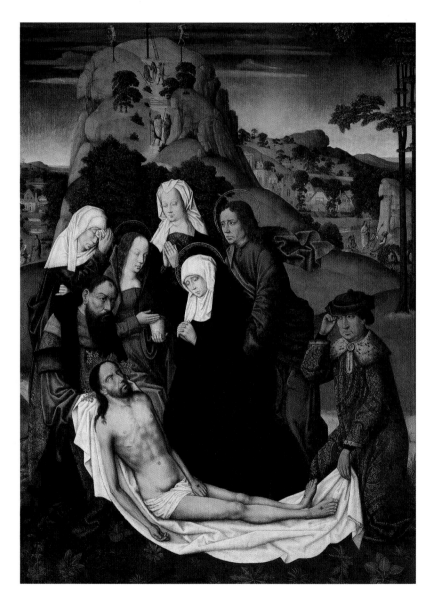

33

Artist unknown
Vesperbild or *Pietà, c.*1410–20
Painted chalk stone, height 65.5 cm

The *Pietà* (literally 'pity') is a devotional image of the Virgin Mary mourning the body of Christ after he was taken down from the cross. Often life-size sculptures of Mary and the dead Christ were placed in churches as a focus for meditation and veneration. The form of the *Pietà* developed significant historical and cultural variations in its stylistic expression: Northern European artists often emphasise Christ's physical sufferings with visceral images, whereas a more classical idealised portrayal is found in Southern European painting and sculpture.

One of the earliest works in the collection, this polychrome, stone-carved *Pietà* was produced in Carinthia (now in southern Austria) and combines some aspects of both traditions. The dead weight of Christ's head and stretched horizontal figure is unfeasibly supported by the more idealised figure of Mary, giving the impression of lightness or levitation. The full impact of the sculpture is experienced when seen from more than one viewpoint: from the position of Christ's head, Mary's sorrow and pain is fully directed and expressed.

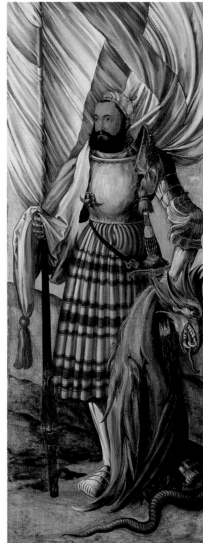

34

Artist unknown

(Franconian Master) (active *c*.1515)
*St Christopher carrying the infant
Christ* (front) and *St Catherine*
(back), and *St George and the
Dragon* (front) and *St Barbara*
(back), *c*.1519
Oil on panel, each panel 102 x 40 cm

This pair of double-sided panels
once formed the wings of an altar-
piece that was probably commissioned
for a private chapel. The central
panel, showing *The Lamentation of
Christ*, is now in the collection of
the National Gallery of Scotland
in Edinburgh. The panel depict-
ing St Christopher (patron saint
of travellers) has on its reverse
St Catherine with the wheel on
which she was martyred, inscribed
'1519'. The front panels were probably
painted by a different hand after
this date.

The panels pose a number of
questions, particularly concerning
the artist responsible. The style is
close to that of the Nuremberg
workshop of Albrecht Dürer
(1471–1528) and his brother, Hans.
The central panel (now in Edinburgh)
bears a portrait of the donors, who
have been identified as members of
the Brandenburg-Ansbach family,
and it has been suggested that the
figure of St George was a likeness of
George, Margrave of Brandenburg-
Ansbach (1484–1543) – a powerful
German magnate who became a
leading supporter of the Lutheran
Reformation in the 1520s.

35

Master of the Polling Altarpiece
(active 1440s)
*St Peter and St Paul, c.*1440
Oil on wood panel,
each panel 93.8 x 39.8 cm

The unknown artist of these panels
derives his nickname from an
altarpiece painted in 1444 for the
Foundation of the Augustinian
Canons in the village of Polling,
near Weilheim in Upper Bavaria.
The works associated with this artist
are characterised by a realistic but
highly expressive style.

This pair of panels was probably
painted in around 1440 for the
inner wings of a similar altarpiece.
The artist produced highly decorated
surfaces, which can be seen in the
architectural interior of tiles, pillars
and vaulting. The panels have a
rich gilded background, decorated
with punchmarks – which can
be seen in the panel depicting
St Peter. St Peter himself can be
identified by his traditional attribute
– the key of heaven – and the richly
embellished vestments that he
wears as the first Bishop of Rome.
St Paul holds the sword with which
he was martyred.

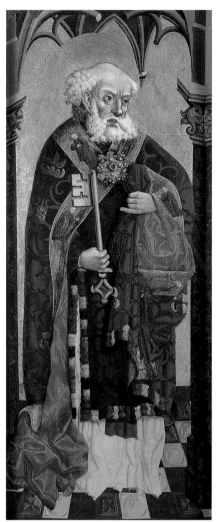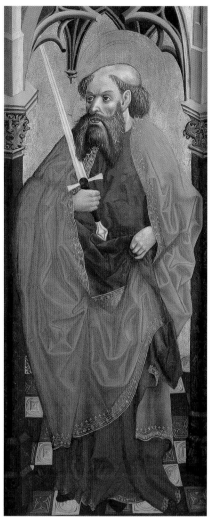

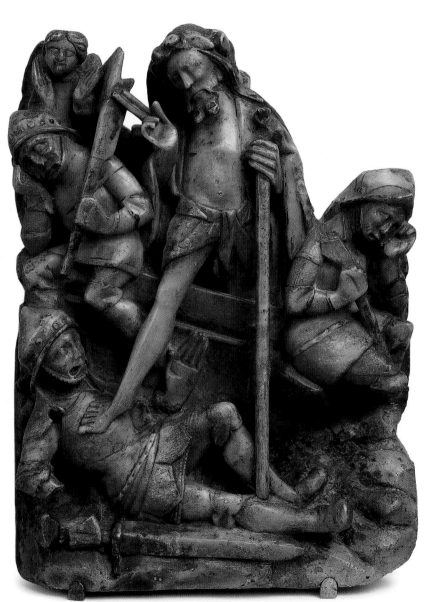

36

Artist unknown

*The Resurrection, c.*1450

Nottingham alabaster relief, 30 x 22 cm

This small relief is an example of the type of work that was being produced outside Germany in the 1400s. Alabaster, a fine-grained form of gypsum (calcium sulphate, or sulphate of lime), became popular for the carving of religious sculpture and altarpieces in Late Medieval England. Important centres of alabaster production developed around the quarries at Newark in Nottinghamshire. During the Reformation, however, many alabaster carvings were destroyed or looted; they are, as a result, now rare in England.

In this scene from the Resurrection, Christ emerges from the tomb, passing over sleeping soldiers tasked with guarding the entrance. The noticeably large hands of the figures are used to emphasise their gestures – a feature that lends particular emphasis to Christ's blessing.

Originally, alabasters such as this one would have been encased in a wooden frame, with doors, and the relief would have been brightly painted and gilded. Traces of the original red polychrome can be seen on the soldiers' mouths and swords and on the angel's wings.

37

Attributed to the Circle of the Master I.P.

The Holy Kinship, c.1520

Polychromed limewood relief, 87.5 x 123 cm

This limewood relief would originally have formed part of an altarpiece. It shows a number of figures, which include the infant Christ supported by the Virgin's father, St Joachim, flanked on either side by the Virgin and her mother, St Anne. The focus of the composition is the interaction between the infant and his grandfather.

This sculpture has been attributed to the circle of the man known only as 'the Master I.P.' on stylistic grounds. Although works by him are extremely rare, the Master I.P. was one of the most versatile and influential carvers in southern Germany in the 1520s. He and his circle worked around Passau and Salzburg, while other works by him are found in Bohemia. The quality of the carving can be seen in the intricate folds of drapery and the treatment of the hair.

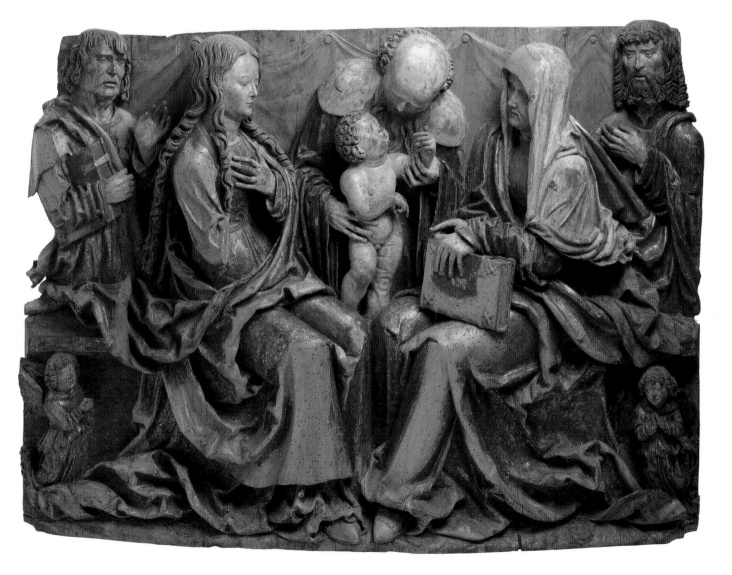

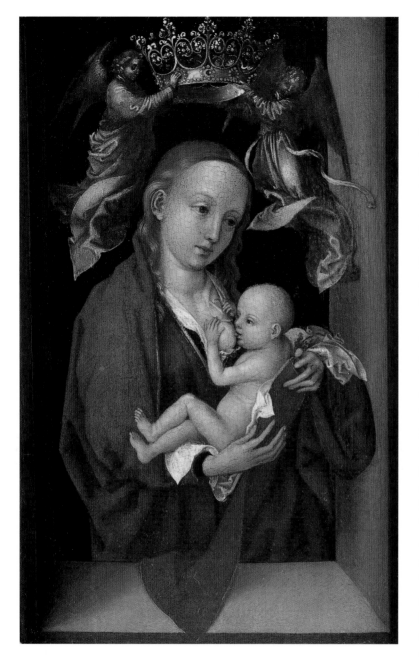

38

Martin Schongauer (*c*.1440–91)
*'Maria Lactans', The Virgin and Child
Crowned by Angels, c.*1470
Oil on softwood panel, 17.5 x 11.5 cm

One of very few paintings by influential Alsatian artist Martin Schongauer in existence today, this small panel is likely to have been made for private devotion, possibly as part of a diptych that included a portrait of its owner. Schongauer was better known for his engravings, which inspired artists all over Europe, including Albrecht Dürer and Michelangelo (1475–1564).

Images were very important aids to devotion. They were used for meditation, awakening the memory of Christ and the Virgin in the devotee, instructing them about their lives and encouraging them to veneration. The Virgin, her red robes projecting from the frame as if inviting us to touch them, and the Christ child, gripping his mother's breast, recall the work of Schonmgauer's Flemish contemporary, Rogier van der Weyden (1399/1400–1464). The dark window frame, like a niche in a chapel, is contrasted with a harmonious ring of light drawing us first to the Virgin's face, downwards to the Child, and up again to the angels and crown. Schongauer conveys in the Virgin's face a sense of motherly devotion mixed with the sorrow of knowing the infant's fate.

39

Master of the Schwabach Altarpiece
(active 1505–08)
Christ Taking Leave of His Mother, 1506
Dated *1506*
Oil and gold on limewood panel, 149.5 x 119 cm

This painting emulates the style of Nuremberg's
most famous painter, Albrecht Dürer. The main
figure group is based on a woodcut print by
Dürer of about 1504. Although the identity of
the painter is unknown, he is believed to have
produced the main panels of an altarpiece for
the church of St John the Baptist and Martin
of Tours in the town of Schwabach, south of
Nuremberg. It was commissioned by a rich
Nuremberg couple, Michael Lochner von
Huttenbach and his wife Catharina von Plauen,
who are depicted with their coat-of-arms and
their children. Michael is shown with their son
(bottom left of the panel) and Catharina with
their daughter (bottom right).

Michael Lochner the Elder died in August
1505, and this work, dated 1506, was possibly
painted to commemorate him.

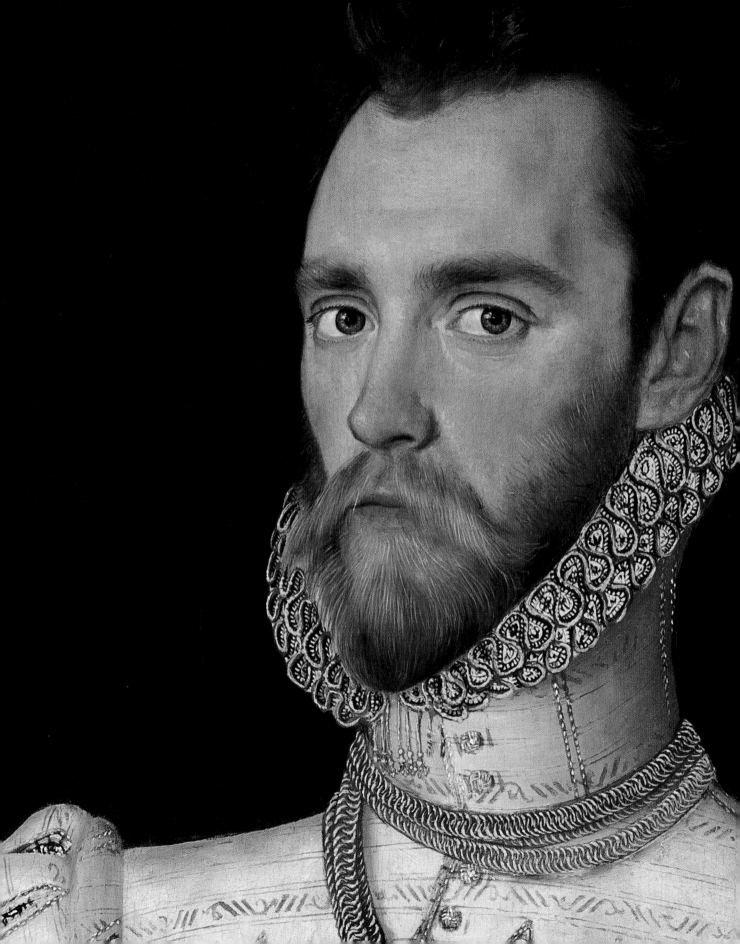

British Portraits

Portraits in Early Modern Britain

Karen Hearn

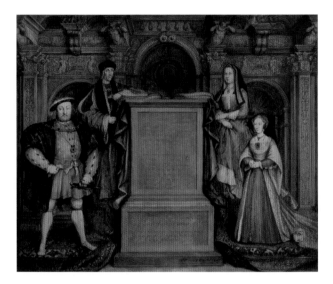

The British have long loved portraits. They have for centuries been enthusiastic commissioners and buyers of images of themselves, of members of their family, of their political allies and of their monarchs.

Very few British portraits survive from before the reign of Henry VIII (r.1509–47). An exception is an enormous seated painting of King Richard II, *c*.1388, in Westminster Abbey. Other rare early British examples are the smaller, head-and-shoulders pictures in the Royal Collection, the National Portrait Gallery and the Society of Antiquaries of London. These early portraits are of members of the royal family and in a few cases of leading courtiers. They are painted on wooden panels; the use of canvas as a support for paintings hardly occurred in Britain before 1600.

Another élite form of portraiture that became fashionable in England was the portrait miniature, which first appeared in both France and England during the 1520s. These were painted, using water-bound pigments, on to the surface of a piece of vellum that had been stuck to paper card. In England, this technique was first used by Lucas Horenbout (1490/95?–1544), a Netherlandish migrant who was employed by Henry VIII. Again, the first miniatures were initially of members of the royal family and then of the most distinguished court figures. Horenbout is thought to have taught miniature-painting – or 'limning', as it was often termed – to the German incomer Hans Holbein the Younger (*c*.1497–1543).

Subsequent leading practitioners of limning were the English-born Nicholas Hilliard (*c*.1547–1617), the French-born Isaac Oliver (*c*.1565–1617), the Englishman John Hoskins (*c*.1590–1665) and his outstandingly talented nephew, Samuel Cooper (1609–72). Among

Cooper's most celebrated works are his portrait miniatures of Oliver Cromwell, of which Compton Verney has a fine example (45).

Almost all the principal portrait painters in Britain were born and trained overseas. The most important of these was Hans Holbein, who worked in London from 1527 to 1529 and again from 1533 until his death in 1543. Holbein worked for Henry VIII, producing innovatory and influential images of the king and members of his family. Perhaps the most important of these was an immense painting on the wall of the Privy Chamber in Whitehall Palace in London. This no longer survives, as it was lost in the fire that destroyed most of the palace in 1698. The mural showed four full-length figures in an ornate Renaissance interior; the most eye-catching one was Henry VIII, depicted at the front with his third wife, Jane Seymour, with, behind them, his late parents, Henry VII and Elizabeth

of York (fig.1). Many copies were made after Holbein's royal images, particularly that of Henry VIII. The Compton Verney collection includes a half-length portrait of Henry (42) that relates to Holbein's prototype, but which is thought to have been painted around 25 years later, during the reign of Henry's daughter, Elizabeth I (r.1558–1603).

Holbein's method of working was to make a portrait drawing first, in front of the sitter, and then to transfer the outlines of the drawing, using a tracing technique, on to the prepared surface of the wooden panel, and thus to use it as the basis over which to produce the painting itself. Once a drawing had been made, it could be employed again and again to make multiple versions of an image. It could also be used by other painters. It might itself be copied or traced – sometimes quite roughly – and the copied pattern in turn serving as a basis for paintings. This was how portrait-images were disseminated in the sixteenth century and it helps to explain why certain portraits survive in numerous versions by various, now unidentified, painters. As mentioned above, some (such as the Compton Verney *Henry VIII*) might have been made many decades later.

This procedure is also relevant to the surviving portraits of Henry VIII's son and heir Edward VI (1537–53). Although Edward's life was so short – he ruled for only six years and died at the age of 15 – a considerable number of images of him survive today. They are evidence of the immense interest during Tudor times in this precious and much-awaited male heir. Compton Verney possesses two fine examples. The portrait depicting Edward at the age of about five is one of a number of surviving versions based on an

unidentified prototype and was presumably produced through the use of a pattern-drawing (40). Indeed, a closely related drawing survives in the Royal Collection – it is similar to the ones produced by Holbein, though it is not by him. The Compton Verney painting shows Edward dressed in red with gold embroidery – fabric that indicates his royal status. He is presented absolutely head-on, just as Holbein had depicted Henry VIII, and this deliberate echo of his father's earlier portrait marks him out as his heir.

In the mid-1540s, another group of portraits of Edward appeared, this time showing him in profile. These images have sometimes been attributed to the Netherlandish incomer, Guillem Scrots (active 1537–53), but they appear again to be by more than one painter. Compton Verney owns one of the most remarkable examples (41), which shows Edward in profile, with a group of plants and herbs that, instead of turning to the sun as heliotropic plants do, are turning to the young king. An elaborate text inscribed beneath, in both Italian and Latin, explains this concept in flattering terms. English portraits of the sixteenth century commonly incorporated written mottoes, although this is an unusually extended example.

Portraits were often made to mark a particular life event: a betrothal or a marriage, the inheriting or gaining of an aristocratic title, or being appointed to a prestigious post. They might be made to record the appearance of an individual involved in marriage negotiations – for instance, to be sent to a potential spouse's family so that their physical suitability could be assessed.

The Protestant Reformation had been introduced in England in the 1530s under Henry VIII and was

consolidated under Edward VI. Protestants – who took the Second Commandment (against bowing down before images) very seriously – were opposed to religious pictures and mistrusted images of every kind. For this reason, in contrast to those countries on the Continent that remained Catholic, almost no English religious paintings have survived from this period. Indeed much religious visual material was destroyed – a practice called 'iconoclasm'.

A major pre-Reformation English product had been religious sculptures carved from alabaster. In the 1530s, production of these ceased and the workshops that continued turned to making funerary monuments. Many alabasters were destroyed, although some that had been exported survived and they have subsequently found their way back into British collections. Compton Verney possesses a fine example (36) displayed in the Northern European galleries.

Edward VI died in 1553 and the Reformation in England was briefly reversed when his Catholic half-sister, Mary Tudor (1516–58), the daughter of Catherine of Aragon (1485–1536) and Henry VIII, came to the throne. In 1554, she married her kinsman King Philip II of Spain (1527–98). Compton Verney has a fine silver medal showing Mary in profile, by the Italian metalworker Jacopo da Trezzo (1519–89) – medal-making was another highly élite form of portraiture and one again in the hands of foreign practitioners. Da Trezzo is known to have been in London in December 1554, having probably accompanied Philip and his entourage to England for his marriage to Mary at Winchester a few months earlier.

In 1558, Mary was succeeded by her half-sister Elizabeth I (1533–1603). With Elizabeth, England became a Protestant country again and so once more religious imagery became problematic. The vast majority of paintings that survive from Elizabeth's reign are portraits.

Elizabeth and her advisers seem to have made various attempts to control the production of portraits of her. Although many of them survive from throughout her long reign, there are comparatively few of top quality. Almost none are signed and few are even by artists whom we can definitely identify. This is the case for the three-quarter-length portrait of Elizabeth at Compton Verney, which dates from around 1590, late in her reign. Elizabeth's later portraits are not at all naturalistic, but show her as an idealised, still youthful – and therefore still powerful – figure. They always show her richly bejewelled and in the finest, most luxurious fabrics, to indicate her royal status. In this case, she wears a crescent-moon-shaped jewel, a symbol of the classical goddess Diana, who was, like Elizabeth, a virgin. Elizabeth's portraits, like those of Edward VI, can be grouped according to 'type' based on successive presumed pattern-drawings.

As noted earlier, the leading portrait painters of the Tudor period tended to be incomers, born and trained on the Continent – generally in the Netherlands – who brought their more sophisticated skills to Britain. Those whose names are known include Gerlach Flicke (active c.1545–58, from Osnabrück in Germany), the Flemish Guillem Scrots, mentioned above, Hans Eworth (active c.1540–c.1574, from Antwerp) and Steven van Der Meulen (active c.1543–1563/4, again from Antwerp), although once again the names of the painters of most of the portraits that survive are now unknown.

From Henry VIII's reign onwards, courtiers

commissioned portraits of themselves. Lifelikeness was not always the top priority – a key purpose was to convey the status of the sitter. Male portraits were designed to indicate the subject's rank, power, wealth, family connections (by including heraldry) and, often, his piety. The portrait of Sir Thomas Knyvet (43), painted in around 1565, is a good example. Female portraits were also constructed to express the sitter's rank and wealth – or rather, that of her family – as well as her fashionableness, virtue, beauty and piety. Portraits invariably idealised the sitter; whatever scars or physical defects they may have suffered from in reality, these are almost never shown.

By the end of Elizabeth's reign, the most fashionable painter was Marcus Gheeraerts the Younger (1561/2–1636), again a man of Netherlandish origin. His best-known work is the large full-length 'Ditchley' portrait, depicting Elizabeth standing on the map of England (National Portrait Gallery, London, c.1592). Elizabeth died in 1603, but Gheeraerts's work continued to be in vogue during the reign of her successor, James I (1566–1625). In 1608, he painted an unidentified aristocratic two-year-old boy, now in the Compton Verney collection (44).

Portraits were still the most popular form of image in England during the Stuart era (1603–1714), again generally produced by Netherlandish incomers. The most significant of these was Sir Anthony van Dyck (1599–1641), born and trained in Antwerp but who, in turn, was also greatly influenced by Venetian painters such as Titian (1485–1576). Van Dyck came to London in 1632 to work for the art-loving King Charles I (1600–49), and the new forms of portrait that he introduced were to be adopted by numerous other artists working there. Van Dyck died in London in 1641, still a young man, just as civil war was about to break out. Throughout the war, the ensuing Commonwealth period and into the Restoration of the Stuart monarchy in 1660 and beyond, Van Dyckian compositions continued to be appropriated by portraitists in Britain.

Van Dyck's images of Charles I had idealised the king, making him look more dynamic and commanding. One of his most celebrated works was a triple head-and-shoulders portrait of the king of 1636, shown from three angles (Royal Collection). The painting was sent to Rome, to enable the sculptor Gianlorenzo Bernini (1598–1680) to make a marble portrait bust of Charles. Unfortunately, the bust was destroyed in the Whitehall Palace fire in 1698, but a number of derivations of it survive. These include one made of lead, probably in about 1675, now at Compton Verney (46).

From about 1660 onwards, other forms of subject matter began to be painted more frequently in Britain: landscape, still life, narrative and animal pictures. However, portraits still continued to be the most common form of commission from British clients throughout the next two centuries. Initially, the most successful painters continued to be incomers: the Dutchman Sir Peter Lely (1618–80), who came to London in the early 1640s, later worked for King Charles II (1630–85) and was succeeded by the German Sir Godfrey Kneller (1646–1723), who painted all the Stuart monarchs from Charles II to Queen Anne (1665–1714) as well as their leading courtiers.

By the Georgian period (1714–1837), British-born portraitists at last began to hold their own. The principal

figure was the London-born William Hogarth (1697–1764), who produced remarkable, characterful portraits of mainly middle-class sitters. In the field of élite portraiture, the long-lived Jonathan Richardson (1665–1745) was succeeded by his prolific son-in-law, Thomas Hudson (1701–79), with whom, from 1740 to 1743, the young Joshua – later Sir Joshua – Reynolds (1723–92) trained. Reynolds was to become the leading painter of his age, portraying people at many levels of society. He was a founder member of the Royal Academy of Arts and became its President. In the portrait of *Mrs Baldwin in Eastern Dress* (48), Compton Verney possesses one of his most beautiful works.

A much rarer medium was a form of coloured crayon, called 'pastel', which was used by a handful of practitioners in Britain. By far the most adept was the widely travelled Swiss artist Jean-Etienne Liotard (1702–89), who worked in London between 1753 and 1755 and again between 1773 and 1775. Liotard also made pastel portraits of Britons abroad, notably during a sojourn in Istanbul in the 1740s. As his image of Lady Fawkener (47) demonstrates, he was able to achieve an exceptional effect of likeness.

Foreign painters who came to Britain hoping to find opportunities to paint narrative subjects – which in the artistic hierarchy were considered more prestigious – invariably found that what British clients wanted were portraits. As Hogarth's French friend, the painter of miniatures in enamel Jean-André Rouquet (1701–58), ruefully observed 'portraiture is the kind of painting the most encouraged, and consequently the most followed in England'. Thus, any serious – and representative – collection of British historical painting, such as that at Compton Verney, is heavily weighted towards portraiture throughout the centuries.

42 (see p.82)
After Hans Holbein the Younger (c.1497–1543)
Henry VIII, c.1560 (detail)

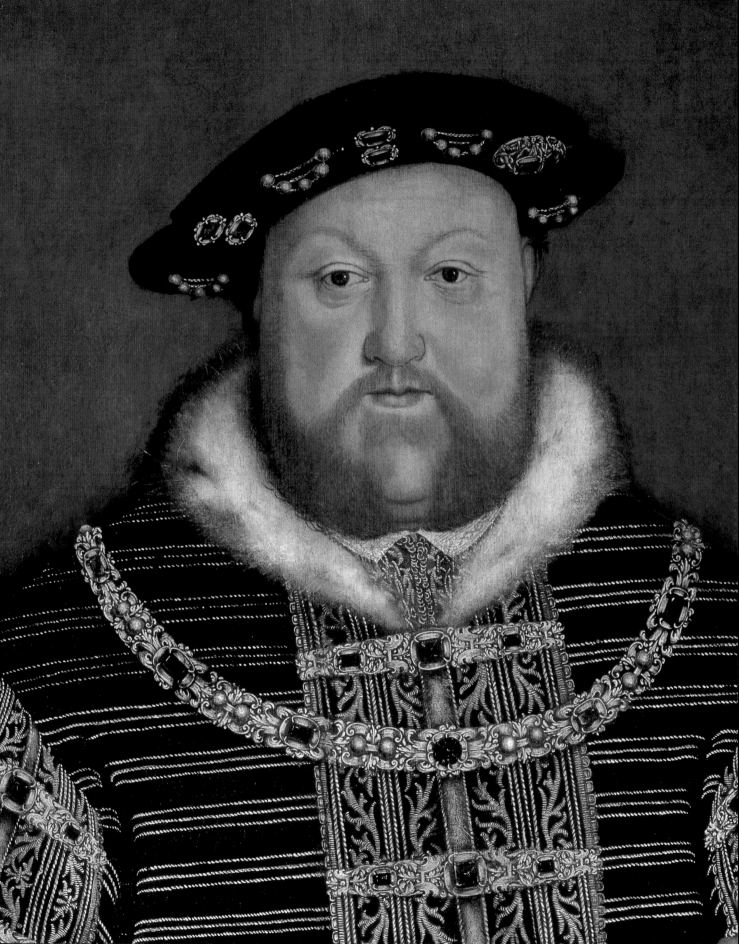

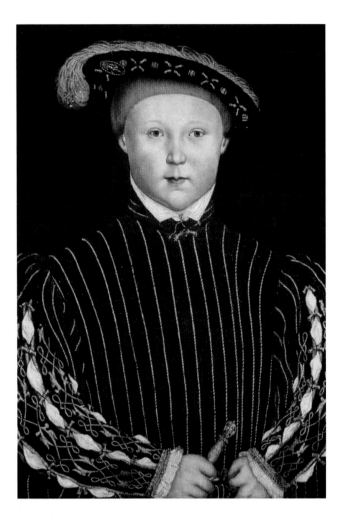

40

Follower of Hans Holbein (1497–1543)
Edward, Prince of Wales, later King Edward VI, c.1542
Oil on panel, 53 x 41.5 cm

Prince Edward (1537–53), the son of Henry VIII (1491–1547) and Jane Seymour (1541–61), was born at Hampton Court Palace in October 1537. His mother died within 12 days of his birth, and as the future king of England he was given a separate household from the age of two.

This portrait, painted when Edward was five, shows him as a diminutive figure of power, wearing a red doublet with gold thread and richly embroidered slashed sleeves. In his black-feathered hat he wears a gold jewel with a reclining lady. Brother to Mary Tudor (1516–58) (who was Catholic) and the Protestant Elizabeth I (1533–1603), both of whom succeeded him, Edward tried to encourage Protestantism in his short reign (1547–53), backing a radical new Prayer Book in 1549 and establishing Protestant schools across the nation. He died from complications arising from a stomach complaint and was succeeded by his half-sister Mary, who attempted to drag England back into the Catholic fold. A number of portraits of him were painted after his death to promote the Protestant cause in opposition to Queen Mary.

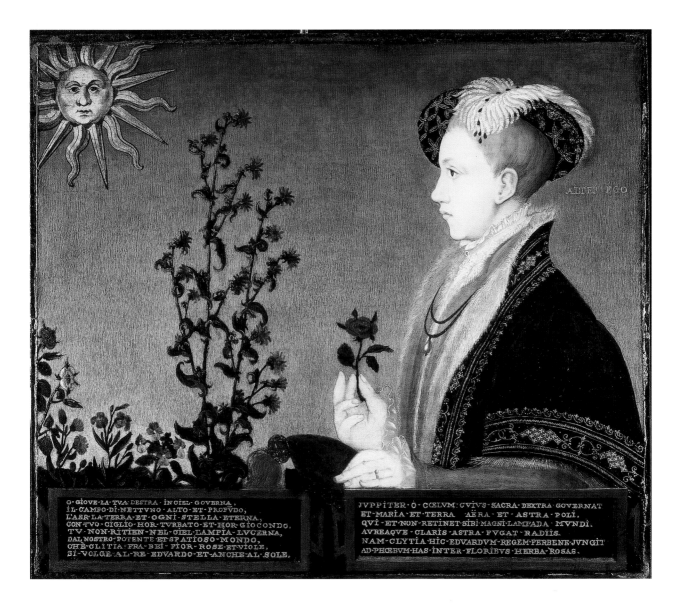

41

Attributed to William Scrots (active 1537–53)
King Edward VI, c.1550
Oil on panel, 58 x 68 cm

This depiction of Edward VI (1537–53) includes both the red and the white rose, emblems of the Houses of Lancaster and York respectively, which were the two dynasties united by Edward's grandfather, Henry VII (1457–1509), in 1485. The inscriptions refer to the power of the king – mightier than the sun.

This portrait may have been painted for the Stanhope family, relations of Edward VI's uncle and chief minister, Edward Seymour, 1st Duke of Somerset and Lord Protector (c.1506–52). It remained in the same family until it was acquired for Compton Verney in 2004.

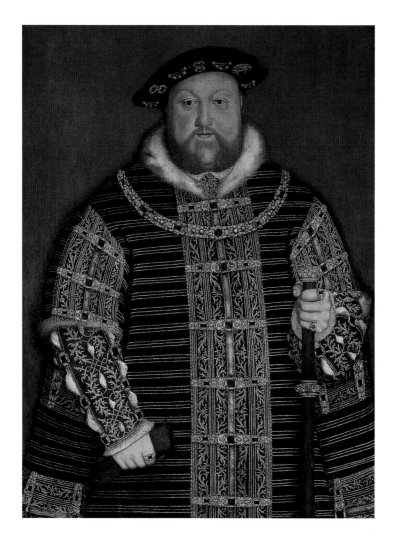

42

After Hans Holbein the Younger (*c*.1497–1543)
Henry VIII, c.1560
Oil on panel, 98.2 x 72.5 cm

This is a version of the last official portrait painted of King Henry VIII, who died in 1547. The original was painted shortly before Hans Holbein the Younger's death in 1543, but it was copied many times.

Henry is a dominating figure dressed in a surcoat lined with ermine and embroidered with gold thread. He wears a jewelled cap and an enamelled gold chain and carries a decorated staff, which both symbolised his status and helped the increasingly gout-ridden king to walk. A contemporary, Edward Hall, described the king's rich appearance in 1540:

> His person was apparelled in a coat of purple velvet, somewhat made like a frock, all over embroidered with flat gold of damask with small lace mixed between of the same gold … the sleeves and breast were lined with cloth of gold, and tied together with great buttons of diamonds, rubies and orient pearl.

Holbein was born in Augsburg, but after 1526 spent most of his working life in England, where he specialised in masterly portraits of the king and his court.

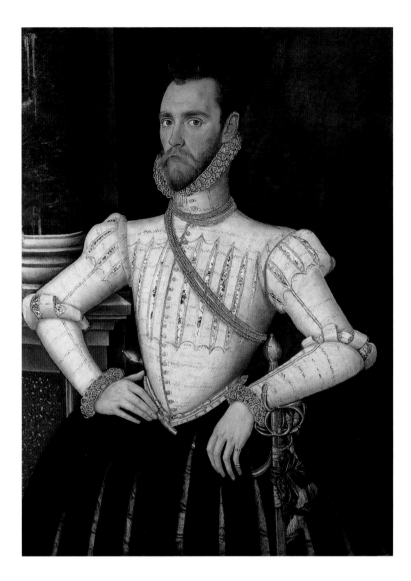

43

Master of the Countess of Warwick (active 1567–69)
Sir Thomas Knyvet, *c.*1565
Oil on panel, 99.1 x 71.7 cm

Sir Thomas Knyvet (1539–1617) was a member of a prominent East Anglian landowning family. He was knighted by Queen Elizabeth I during her Royal Progress in Norfolk in 1578; this was followed by another honour the next year when he became High Sheriff of Norfolk. He and his wife, Muriel (daughter of Elizabeth I's Treasurer of the Household), lived at Ashwellthorpe in Norfolk.

This portrait shows the sitter very fashionably dressed in order to emphasise his wealth and status. He wears a white, slashed doublet and double ruffs edged with gold, and carries an elaborate sword with a green-and-gold sash and a matching dagger at his back.

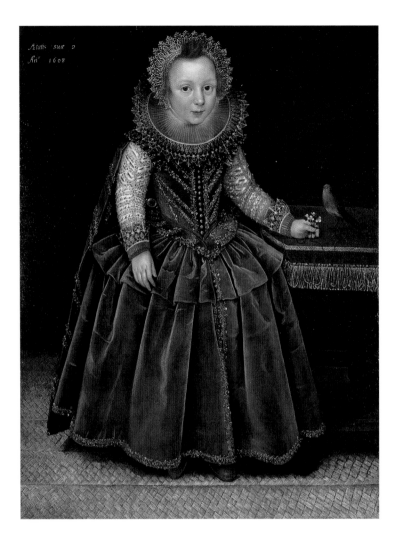

44

Marcus Gheeraerts the Younger (1561–1636)
A Boy Aged Two, 1608
Inscribed and dated *Aetatis suae 2/ An° 1608*
Oil on panel, 98.2 x 72.5 cm

This little boy is two years of age. He wears a dress, with a bodice and a skirt over a farthingale frame; this was a typical manner of clothing a boy until he was 'breeched', at the age of around five or six years old, when he would be dressed in breeches or trousers. He carries a small dagger, the handle of which can be seen sticking out of his waist near his left elbow. In his left hand he holds a bunch of flowers and a string attached to a robin. The flowers are pansies or 'heart's-ease', symbolising innocence and transience, which could be a reference to the high rate of infant mortality in the period. The bird could also refer to the notion of the human soul flying away at the moment of death.

Marcus Gheeraerts the Younger was the son of a successful Flemish painter. Born in Bruges, he moved to London at the age of seven. Here he received many commissions from the English court and became known for his depictions of 'sweet melancholy', of which this is an excellent example.

45

Samuel Cooper (1608–72)
Oliver Cromwell, 1657
Watercolour on vellum, height 10.4 cm

Oliver Cromwell (1599–1658) was one of the most outstanding figures in British history. A radical puritan, during the English Civil War he helped Parliament to establish a professional army known as the 'New Model Army'. At the end of the First Civil War in 1645, he rapidly emerged as one of the most powerful and influential of the parliamentarian army's generals, and was instrumental in bringing King Charles I (1600–49) to trial and execution, thus making England a republic, in 1649. In 1653, with support from the moderate army generals, Cromwell had himself created Lord Protector of the English Commonwealth – effectively establishing him as the nation's ruler.

This portrait was painted a year before Cromwell's death in 1658. After his death, his son Richard markedly failed to win support from either the army or parliament, and in 1660 Charles I's eldest son was restored to the throne as King Charles II (1630–85).

Samuel Cooper was one of the most important and influential portrait miniaturists of the day. Painted in 1657, this portrait of Cromwell, wearing simple armour, has been referred to as 'one of the most penetrating studies of a public figure ever produced'. It is believed that Cromwell's celebrated comment, urging the artist to paint him 'pimples warts & every thing as you see me', relates to this portrait.

46

After a bust by Gianlorenzo Bernini (1598–1680)
King Charles I, c.1675
Painted lead, height 66 cm

This important work is one of only three versions of
Gianlorenzo Bernini's original marble bust of Charles I
made 40 years previously. Bernini had not modelled
the piece from life, but had made it in Italy using
Anthony van Dyck's (1599–1641) superb 1635
portrait of Charles's head in three positions as a
guide. This version was possibly made by the English
sculptor John Bushnell (1636–1701), who trained in
Italy in the 1660s. Bushnell made many studies of
Bernini's sculptural works and is known to have
created a statue in 1671 of Charles I for the
Royal Exchange in London (now at the Old
Bailey) in Purbeck stone, which also used
Bernini's bust as a model. Twenty-three
years after the creation of this copy,
Bernini's original was lost in the 1698 fire that
destroyed most of Whitehall Palace in London.
Charles I was a passionate collector of art and
an enthusiastic patron of contemporary artists such
as Peter Paul Rubens (1577–1640), Van Dyck and
Bernini. Following his execution in 1649, much of
Charles's painstakingly assembled collection was sold,
although many items were recovered for the
Crown after his son's restoration to the throne
in 1660.

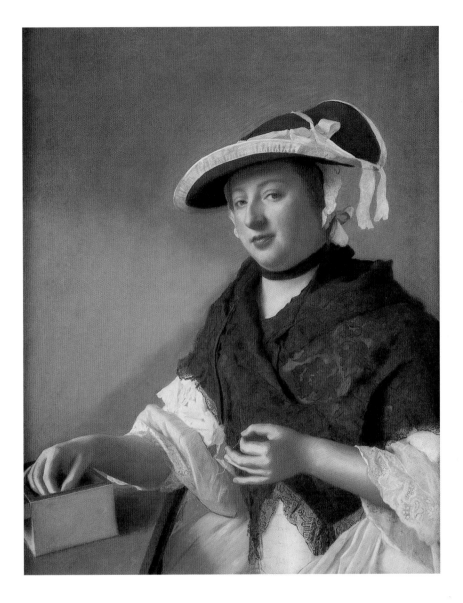

47

Jean-Etienne Liotard (1702–89)

Portrait of a woman, called Lady Fawkener, c.1760

Pastel on vellum, 73.6 x 58.8 cm

The sitter is Harriet Churchill (*c.*1726–77), the wife of Sir Everard Fawkener (1694–1758), English ambassador to Constantinople (now Istanbul) from 1737 to 1746. Fawkener and the Swiss pastel painter, Jean-Etienne Liotard, had become acquainted in the Turkish capital, where the artist produced portraits for members of the British colony.

Liotard probably produced this pastel portrait on one of his visits to London, in 1754–55. The use of pastel (a soft chalk-based medium) allowed the artist to create delicate effects. These can be seen in the black lace shawl and the soft flesh tones of the sitter's face and arms. Lady Fawkener holds a thread in her left hand, while picking something out of a box with her right hand. Her husband's family business was the silk trade and it is possible that the thread is a reference to this occupation.

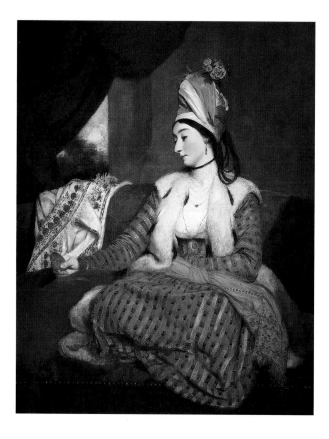

48

Sir Joshua Reynolds (1723–92)
Mrs Baldwin in Eastern Dress, 1782
Oil on canvas, 141 x 110 cm

Mrs Jane Baldwin (1763–1839) was the daughter of William Maltass, a merchant who traded in the eastern Mediterranean via the Levant Company. Born in Smyrna in the Ottoman Empire in June 1763, she married George Baldwin, a rich merchant who later became British Consul in Alexandria.

This picture demonstrates Sir Joshua Reynolds's love of the exotic, already seen in portraits such as the celebrated *Omai* of *c.*1776 (Private collection). Mrs Baldwin was herself something of a celebrity eccentric and is depicted in a suitably outlandish Persian costume. She quickly became bored with Reynolds's sittings and while posing she preferred to read a book – which Reynolds transmuted into 'an ancient coin of Smyrna', a gesture that many critics, then and since, thought somewhat heavy-handed.

Mrs Baldwin's 'Persian' costume, with its green-and-gold kaftan and sleeveless ermine overgown, was in reality a fancy dress outfit, which she had worn to a ball given by King George III (1738–1820).

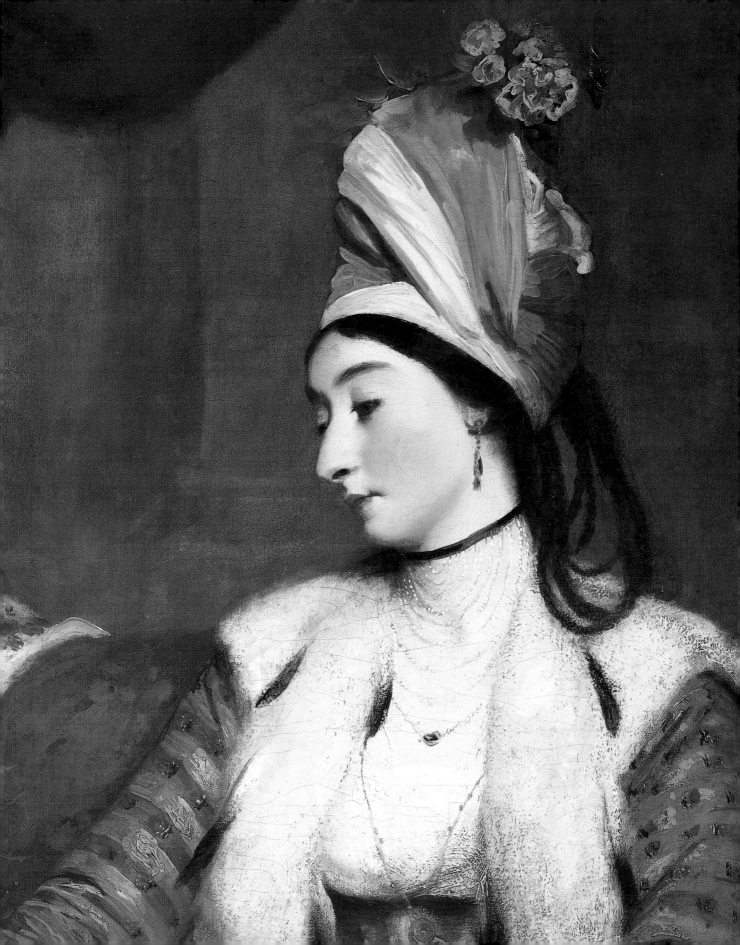

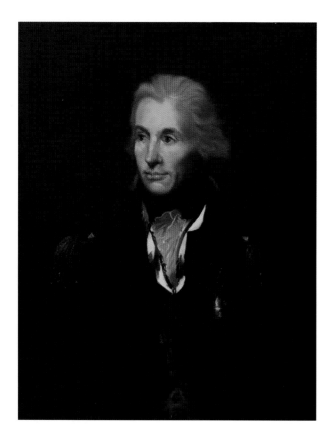

49

Lemuel Francis Abbott (1760–1802)
Horatio, Admiral Nelson, KB, 1797
Oil on canvas, 76.2 x 63.5 cm

Admiral Lord Nelson (1758–1805) remains the most illustrious of all of Britain's naval heroes. In 1797, while in command of HMS *Captain*, he distinguished himself by his impetuous heroics at the significant Battle of Cape St Vincent; shortly after, he was seriously wounded at the Battle of Santa Cruz de Tenerife, as a result of which his right arm was amputated at sea by a ship's surgeon. (Within half an hour of the operation, he was back in command on his flagship, issuing orders to his captains.)

This portrait was painted on Nelson's return from the engagement, while he was convalescing in Greenwich at the home of one of his captains, William Locker. Nelson was still in considerable pain at this time and sought medical advice on his arm – although when news reached him of Admiral Duncan's (1731–1804) crushing victory over the Dutch at the Battle of Camperdown, he declared that he would have given his other arm to have been present. Recovering from his wound the following year, Nelson returned to sea, won a decisive victory over the French at the Battle of the Nile and remained in the Mediterranean to support the Kingdom of Naples against a French invasion. He was killed while winning the most celebrated of his several victories, at the Battle of Trafalgar in 1805.

After Nelson's death, this portrait was purchased by Francis Grant, Laird of Kilgraston; thus it has become known as the Kilgraston Sketch.

Leicestershire-born Lemuel Abbott was a pupil of the painter Francis Hayman (1707/8–76). Although he exhibited at the Royal Academy, Abbott never became an Academician. In about 1801, he needed to be treated by Dr Thomas Munro, a specialist in mental disorders who had also attended King George III. Abbott died in London on 5 December 1802.

50

Sir William Beechey (1753–1839)

Mirza Abu'l Hassan Khan, 1809–10

Oil on canvas, 144.2 x 137.8 cm

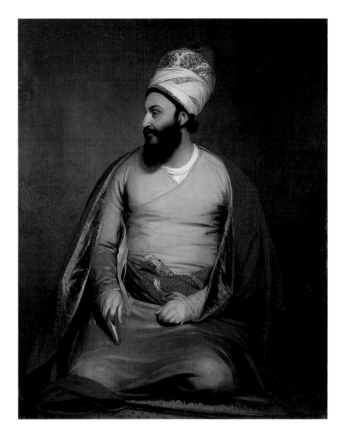

In 1809, Mirza Abu'l Hassan Khan was despatched as ambassador to the court of King George III by the Shah of Persia, to help negotiate a treaty of alliance between Great Britain and Persia (now Iran). Britain was then facing Napoleon's Empire alone and was desperately in need of foreign alliances. The ambassador therefore became an intriguing focus of diplomatic activity and many parties were held in his honour by both Spencer Perceval's government and by George III. Abu'l Hassan – who left a published account of his experiences while in England, which detailed his visits to Sir William Beechey's house in London's Harley Street – was also fêted by artists during his stay: Beechey painted him twice, the other being a full-length exhibited at the Royal Academy in 1810 and now in the India Office Library, while Sir Thomas Lawrence (1769–1830) painted a three-quarter-length (1810, Fogg Museum, Harvard University Art Museum).

In Beechey's impressive painting at Compton Verney, Abu'l Hassan is not depicted as an exotic or an eccentric in the manner of Reynolds's *Mrs Baldwin* of 20 years' earlier (see 48). Instead, the ambassador poses in his relatively modest, though colourful, official robes with an air of calm authority. On his return to Persia, Abu'l Hassan was created a Khan in recognition of his diplomatic success.

By 1809, Beechey had become one of the nation's foremost portrait painters. Appointed portrait painter to Queen Charlotte (1744–1818), wife of George III, in 1793, he later fell out with the king over his association with the raffish court of the heir to the throne, George, Prince of Wales (1762–1830) – later Prince Regent; however, support from the Duke of Gloucester, from the royal Duke of Clarence (who, on his accession to the throne as King William IV (1765–1837) in 1830, appointed Beechey as his principal portrait painter) and from a variety of aristocratic and mercantile clients ensured that his practice remained successful.

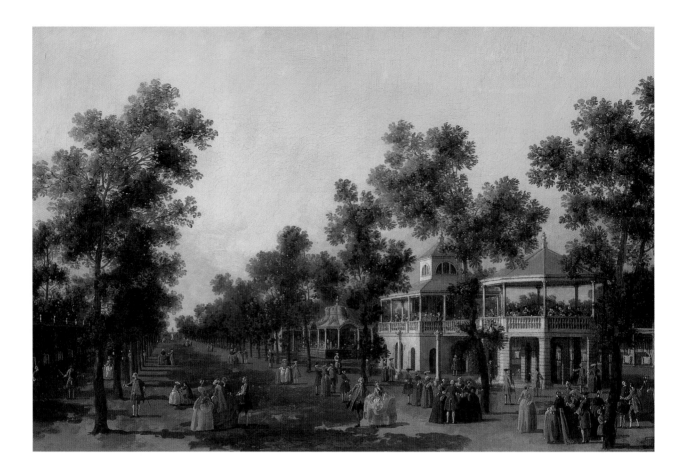

51

Giovanni Antonio Canal (known as Il Canaletto)
(1697–1768)
The Grand Walk, Vauxhall Gardens, c.1751
Oil on canvas, 70 x 96 cm

In 1746, Venetian painter, etcher and draughtsman Canaletto moved to Britain. Here he hoped to secure patronage from many of those who had been on the Grand Tour and for whom he had worked in Italy. He remained in England until 1755, producing views of London and of regional castles and houses for patrons who included the Dukes of Northumberland, Richmond and Beaufort.

In Canaletto's day, Vauxhall Gardens was one of the most fashionable venues for public entertainment in London. Its clientele regularly included the Prince of Wales (1707–51) (ground landlord of the site), royal dukes, aristocrats and wealthy landowners and merchants. One of the great attractions of the gardens was that anybody who could afford the one shilling admission could mix with such people on an equal footing.

Located in Kennington, on the south bank of the River Thames, and known as New Spring Gardens until 1785, Vauxhall Gardens also became a venue for musical performances – including a rehearsal of George Frideric Handel's (1685–1759) *Music for the Royal Fireworks* in 1749, which attracted an audience of 12,000. The grounds developed over time to include a Chinese pavilion, a Gothic orchestra, ruins, arches and statues. They also attracted, from the early eighteenth century, scores of high-class prostitutes plying their trade.

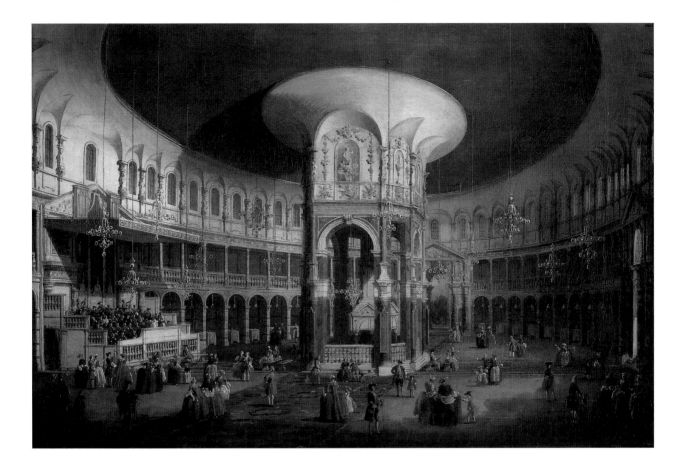

52

Giovanni Antonio Canal (known as Il Canaletto)
(1697–1768)
The Interior of the Rotunda, Ranelagh, 1754
Oil on canvas, 70.5 x 96 cm

This painting depicts the rococo rotunda that formed the centrepiece to Ranelagh Gardens in Chelsea. Ranelagh was a public pleasure garden, similar to the much older Vauxhall Gardens, which had opened in 1742. It was deliberately pitched as a more upmarket rival to Vauxhall: the entrance charge was two shillings and sixpence, compared to a shilling at Vauxhall. The rotunda, designed by William Jones (surveyor to the East India Company, who also worked at nearby Honington Hall, Warwickshire), included a central support with a chimney and fireplaces for use in winter.

In 1765, the nine-year-old Wolfgang Amadeus Mozart (1756–91) performed in the rotunda. The building itself was demolished in 1805 but, while Vauxhall Gardens closed in 1859, Ranelagh survived to become incorporated into the grounds of Chelsea Hospital and the site of the present-day Chelsea Flower Show.

This is one of two interior views of the rotunda painted by Canaletto, the other being in the National Gallery, London.

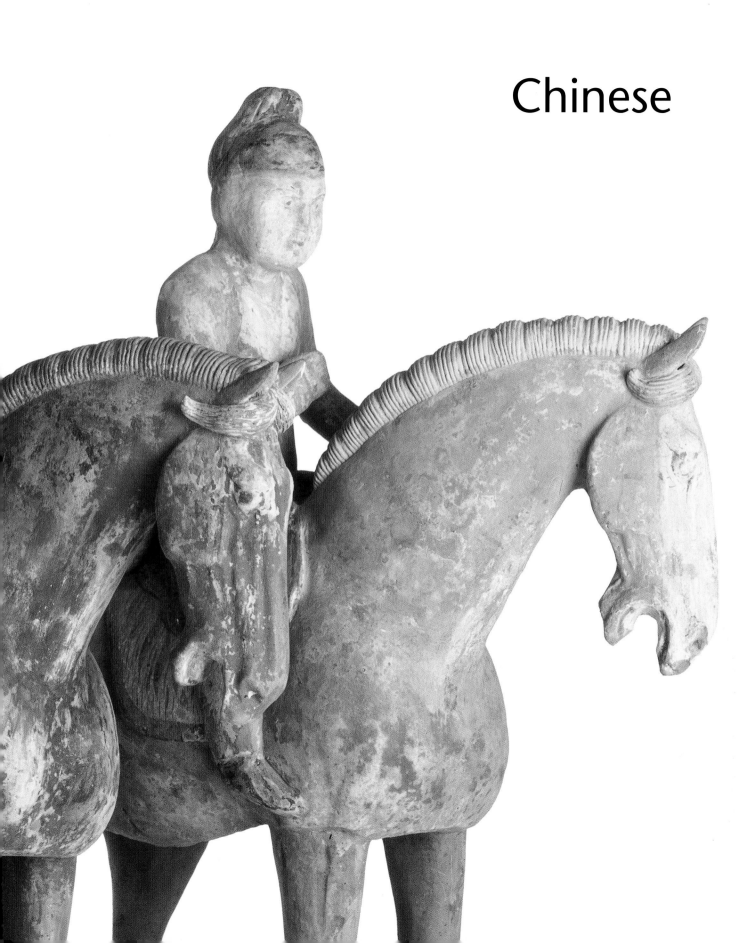

Chinese

Chinese Historical Periods and Dynasties

Neolithic Period	*c.*4500–*c.*2000 BC
Xia Dynasty	*c.*1600–1045 BC
Shang Dynasty	*c.*1500–1050 BC
Western Zhou Dynasty	*c.*1045–770 BC
Early Western Zhou	*c.*1050–*c.*950 BC
Middle Western Zhou	*c.*950–*c.*850 BC
Late Western Zhou	*c.*850–*c.*771 BC
Eastern Zhou Dynasty	770–221 BC
Spring and Autumn Period	770–475 BC
Warring States Period	475–221 BC
Qin Dynasty	221–207 BC
Han Dynasty	207 BC–AD 220
Three Kingdoms	220–280
Jin Dynasty	265–420
Sixteen Kingdoms	304–439
Southern and Northern Dynasties	420–589
Sui Dynasty	581–618
Tang Dynasty	618–906
Five Dynasties	906–960
Liao Dynasty	907–1125
Song Dynasty	960–1279
Yuan Dynasty	1271–1368
Ming Dynasty	1368–1644
Qing Dynasty	1644–1911
Republic of China	1911–1949
People's Republic of China	1949–present

The Art of Bronze Age China
Wang Tao

Chinese bronze art of the second and first millennia BC was one of the most distinctive landmarks in the history of world art. It began with the invention of a new material, bronze, an alloy of copper and tin. Through the mixing and melting of different ores in various proportions, a substance was created that was harder, more enduring and more colourful than anything ever seen before. We are not sure whether the secret of making bronze was discovered independently in China, or whether it was brought to China from the West and from Central Asia, where bronze seems to have appeared earlier than in China. Nonetheless, from the beginning, bronze was used very differently in China than elsewhere: while in the West it was employed for weapons and production tools, in China it was mainly used for ritual objects and vessels. This gives a different perspective to our view of the 'Bronze Age'.

Early Chinese bronzes were made using the piece-mould method. This innovative technology usually (though not always) involved a clay model and a variety of ceramic moulds and cores. From a technical point of view, it was closely associated with pottery traditions of an earlier period. The potters of the Neolithic cultures were highly skilled in shaping and firing a range of pottery vessels that included bowls, cups, ewers, jars and tripods (64). These vessels were richly decorated – either painted or incised – and with a wide range of motifs. For example, the Yangshao culture (c.5000–3500 BC) was known for its hand-built pottery that was painted and fired at a high temperature, while the Dawenkou and Longshan cultures (c.4000–2000 BC) developed a skilful use of advanced wheel-throwing techniques and, by reducing the atmos-

pheric control in the kiln, produced fine eggshell-thin black vessels.

While these techniques laid the foundations for the development of bronze art, the production of a bronze vessel was quite different from that of a pottery one: it required a substantial investment of resources, including the coordinated mobilisation of skilled craftsmen. The extraordinary effort involved in the production of bronze vessels, and the contexts in which they have been discovered, indicate that they were intended for special ceremonies and rituals, rather than for everyday use.

The modern viewer who tries to appreciate Chinese bronzes comes across an immediate obstacle: that of function. This difficulty is reflected in the traditional classification of bronzes. In Chinese texts they are given names such as *ding* (61), *gui* (56 and 57), *dou* (63), *jue*, *jia*, *hu*, *you* and *zun* (62), which are known from classical literature. The textual records also provide explanations of how the vessels were employed in early rituals. For example, in the *Zhouli* ('Rites of Zhou'), the *ding*-tripod is described as a meat-offering vessel, and the stemmed *dou*-bowl as a vessel for meat sauces and pickled vegetables. Other texts such as the *Yili* ('Book of Rites') and *Liji* ('Records on Rites') also contain detailed information about the ways in which the ritual vessels were used. But, while this information is vivid, we must use it with caution. There are many cases in which the nomenclature is incorrect and descriptions state how certain vessels should be used, rather than how they were actually used.

Thanks to modern archaeology, we can now analyse the changes and transformation of bronzes over the long period of their production and use. This

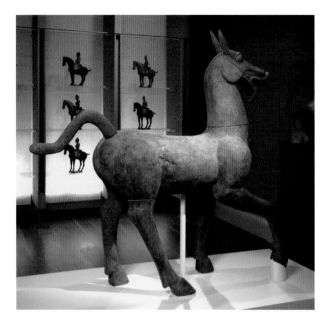

Fig.1
View of the Chinese gallery
© Compton Verney

period of about 1500 years includes the Xia, the Shang and the Zhou dynasties. At the Erlitou site in central China, which dates from the early to the middle of the second millennium BC, bronzes were discovered both in tombs and in residential remains. The Erlitou culture may, or may not, be representative of the Xia dynasty; this is still under scholarly debate. Bronzes from Erlitou include a few tools, weapons and small bells, but mainly consist of vessels such as tripods, ewers and goblets. The bronze vessels still bear certain characteristics of the primitive stage: they are always round or oval in cross-section, with thin walls, mostly plain or very simply decorated. In the final phase of the Erlitou culture, ritual vessels began to appear in matching sets, suggesting that a reasonable scale of bronze production was already in place. In addition to the bronze vessels, there are bronze plaques with face-motifs and dragons created with turquoise inlay, which were probably worn by religious leaders.

The establishment of the Shang dynasty (c.1600–1045 BC) in central Henan brought with it some further innovations in bronze art. Ritual bronze vessels from the metropolitan areas, such as Zhengzhou and Anyang, had a more stylised design and decoration, and were usually made in regular sets. In terms of decoration, the *taotie* (or two-eyed motif) was dominant. This is essentially a hybrid face. There were also a number of animal motifs, in particular the ox, sheep, tiger and dragon. Close observation shows that the motifs first appeared in thread-like low relief on the surface of the bronze vessels, suggesting that they were carved directly into the moulds with a knife before casting. However, the decoration on bronzes soon became more elaborate. The *taotie* appeared in bold designs, and other motifs such as stylised dragons and abstract geometrical patterns became prominent. In Shang art, anthropomorphic motifs were rarely seen in a representational manner. We can be fairly certain that no life-size bronze statuary was made in Anyang, although the skills, materials, knowledge and technology were certainly sufficient and advanced enough had the Shang wanted to do so. The absence of life-size bronze statuary at Anyang may be associated with stylistic fashion, or, more probably, with the social and religious systems of the Shang people.

However, there were human representations in bronze from places outside Anyang, in particular from the south. 'Shang style' bronzes have been found at Funan (Anhui), Xingan Dayangzhou (Jiangxi) and Huangpi Panlongcheng (Hubei), all in the south; but also in the north at Gaocheng Taixi (Hebei), Pinggu Liujiahe (near Beijing) and Huixiang (Henan). These were either colonies established by the Shang people or cultures under the Shang influence. In each case, there is a local element in the bronze art and the decoration is more naturalistic. The amazing discovery in the mid-1980s of the bronze heads and statuary at Sanxingdui (Sichuan) confirms that a distinctive

Bronze Age culture, roughly contemporary with the Shang dynasty, flourished in south-west China. The figurative art of the Sanxingdui culture was very advanced: there was a life-size standing figure cast in bronze and a number of heads showing different features, all of exceptionally high sculptural quality. The heads were originally painted with pigments or covered with gold foil and may once have been fixed to wooden bodies. Many scholars believe that the figures were originally placed in a temple and that the standing figure represented the high priest. In other words, the models may have represented 'real' people. But even if we follow the theory that the majority of the figures and heads were intended to represent the participants in a ritual, we cannot ignore the fact that they are highly stylised and uniform. The striking larger bronze masks, measuring between 70 and 134 cm, with huge ears and with the pupils of the eyes protruding, are more likely to represent deities than men. These may originally have been fastened to trees or wooden poles for worship. The figurative art of Sanxingdui gives us a very different visual impression of early Chinese art than was previously recognised. But the religious belief of the Sanxingdui people is even more remote from us than that of the Shang, and art historians have found it difficult to interpret the meanings of these bronze images.

The Shang dynasty was overthrown in the mid-eleventh century BC by the Zhou people from the north-west, who established their own new dynasty. Surprisingly, although the Western Zhou dynasty (1045–770 BC) lasted a long time and produced a large number of bronzes, there was little innovation in the production of bronze vessels. Wine sets, in particular the *jue*, *jia* and *gu*, gradually disappeared, probably as a result of reforms to rituals that were instituted by the Zhou kings. The main change during the Zhou dynasty was the attention given to inscriptions in bronze art. These recorded important ceremonies or special dedications to the ancestors, and even legal cases and state legislation. We also see more bronze musical instruments (68), indicating the increasing use of music in ceremonial contexts.

The Eastern Zhou period (770–221 BC) saw enormous and rapid social changes. These stimulated new fashions in artistic production. Creative experimentation with materials opened up greater possibilities for both decorative and representational art than ever before. There are examples of human figurines made in jade and lacquered wood, as well as in bronze. Growing commercialisation and interaction between different ethnic groups also contributed to changes in ritual bronzes. By 600 BC, iron began to be used for weapons and agricultural tools. Precious metals such as gold and silver were used as inlays or gilding and occasionally for making vessels, but bronze was to remain the metal of prestige.

Why was bronze so important in China? Bronze artefacts, in particular ritual vessels, played a significant role in the conceptualisation of the political legitimacy of the rulers of dynasties and were perceived as spiritual objects that bestowed heavenly blessings. The significance attributed to bronze ritual vessels is illustrated in the well-known story in the *Zuozhuang* ('Zou's Commentaries'), written around the seventh century BC, at the beginning of the final phase of the Bronze Age. In the third year of Lord Xuan (605 BC), the Duke of Chu attacked the nomads in the north, then took his army

to the Zhou capital at Luoyang for a military parade, with the intention of taking power from the weakened king of the Zhou dynasty. He was greeted by the Zhou king's minister, Wangsun Man. The Duke of Chu opened their meeting by asking the size and weight of the bronze *ding* tripods at the Zhou court. In his reply, Wangsun Man explained that the size and weight of the tripods were of little relevance; what mattered was the virtue that they possessed. He explained that in ancient times, when the Xia dynasty was distinguished by its virtue, the people of distant regions made drawings of many creatures. The nine governors (of the nine provinces) sent these drawings to the king, along with the metals that they paid in tribute. The tripods were cast with all the creatures as decorations so that the people might recognise the outward forms of spirits and demons. Therefore, evil could be averted when people went to the rivers, marshes, hills and forests; they would be able to avoid the spirits of the waters and mountains and all sorts of other monstrous things. The tripods were used to harmonise the world above and the world below. But when Jie (the Xia king) lost his virtue, the tripods were transferred to the Shang and remained with them for 600 years. When King Zhou (the Shang king) became violent and obsessive, the tripods were passed on to the Zhou. Wangsun Man further explained that, when virtue is massive and brilliant, the small tripods become heavy; but when virtue is obscured with wickedness and deception, the large tripods become light. Heaven blesses brilliant virtue and will stay with those who possess it. King Cheng (of Zhou) had settled the tripods in the capital and divination had predicted that the dynasty would last for 30 generations and over 700 years. This was the mandate of heaven. Although the Zhou dynasty's virtue was now in decline, the mandate had not yet changed. Therefore, there was little point, concluded Wangsun Man, in asking the weight of the tripods.

The archaeological notion of the 'Bronze Age' is a western invention, but it largely coincides with three dynasties in Chinese history: the Xia, the Shang and the Zhou. It was during this period that 'state' formation entered a crucial stage and the basic characteristics of Chinese civilisation developed. Historians regard the three dynasties as the 'golden age', whose institutions, philosophy and ritual vessels serve as models and inspiration to later generations. The bronzes are not only physical evidence of the glorious past, but also make a long-lasting visual impact on the modern viewer.

66 (see p.116)
Wine vessel and cover or *fangjia*, date unknown (detail)

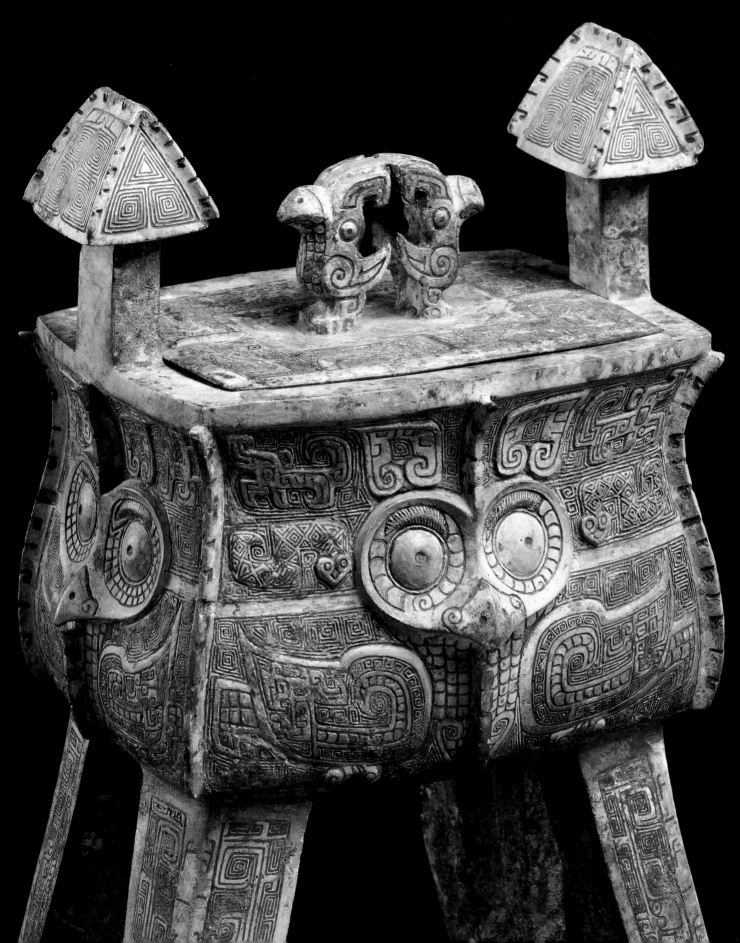

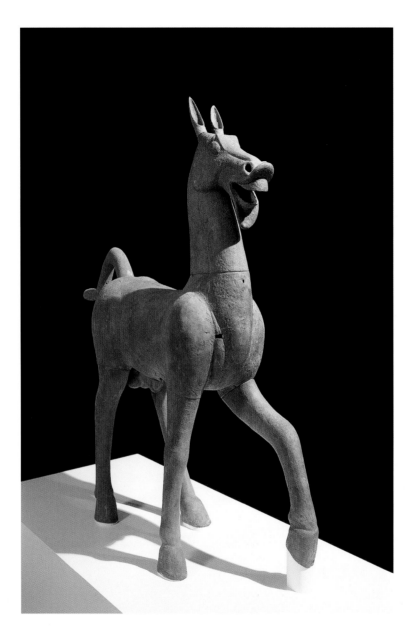

53
Heavenly Horse or *tian ma*, date unknown
Han dynasty
Bronze, height 116 cm

This impressive horse would have been a funerary offering for the tomb of a Chinese nobleman. During this period, horses were only used by the Chinese to pull carriages or war chariots and not for riding; this horse was therefore intended to pull the deceased's chariot in the afterlife.

Such large bronze horses were very rare in this period. It was extremely difficult to produce such sizeable bronze figures in one mould: this stallion is cast in nine close-fitting pieces – a form of production that was very labour-intensive and therefore highly expensive.

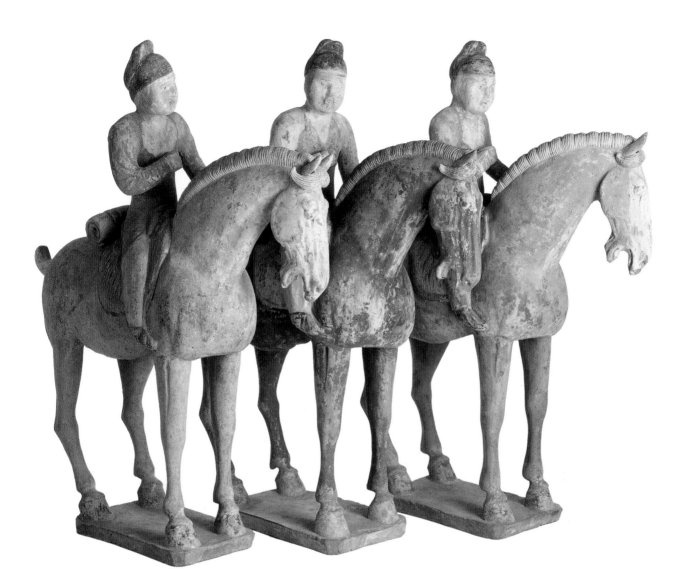

54
Set of twelve painted equestrian figures, C.AD700–800
Tang dynasty
Pottery, each 48.5 cm high

These horsemen would have been buried in the tomb of an ancestor. They are part of the complex ancestor cult that dominated Chinese religious belief and they would have been buried with a number of other figures to prepare the deceased for the afterlife.

Each horse is finely modelled, with an expressive face and a long mane made of a number of separate strands of applied clay. The tail is docked and tied with a cloth cover. The individual riders are seated on a saddlecloth, which is painted either as the skin of a tiger or of a leopard. Each rider has a blanket rolled up behind the saddle and two have a cloth of provisions tied around their waist. Riders and horses are painted with delicate red, white, green and black pigments.

55

Two Guardians, C.AD1400–1500
Ming dynasty
Gilt-bronze, height 112 cm

These imposing figures, cast in bronze and gilded, represent two of the Four Heavenly Kings (*si da tian wang*), or Guardians of the Four Quarters. Of Buddhist origin, the figures took the form of warriors in Chinese culture and would have been situated at the entrance to a temple in order to protect against evil spirits and Barbarian invasion. Dressed in full armour and standing in martial positions, their poses befit warriors whose attention should never falter.

The imagery of the Four Heavenly Kings was also adopted into the Daoist (or Taoist) tradition, from which these figures originate. One bears a sword and may be identified with the Guardian of the West (called *Ma*), while the other holds a 'stupa' (a small pyramid or dome-shaped memorial shrine) and is thought to be the Guardian of the East (called *Li*). The remaining guardians, known by the names of *Chao* and *Wên*, would have held two swords and a spiked club respectively.

56
Ritual vessel or *gui*, c.1100BC
Late Shang dynasty
Bronze, height 15.3 cm

A *gui* was a ritual vessel used for offering food. Prior to this period, these vessels were made without handles, but by about 1100BC they were generally equipped with two. This example is magnificently decorated with a number of motifs that occur regularly in the decoration of Chinese bronzes. Coiled dragons, a motif that seems to have been first used at the beginning of the Western Zhou period, appear on the neck of the vessel and on the base. The handles, with their bovine masks, are also typical of the decorative features of Western Zhou pieces; more unusual, however, are the five rows of studs on a lozenge background.

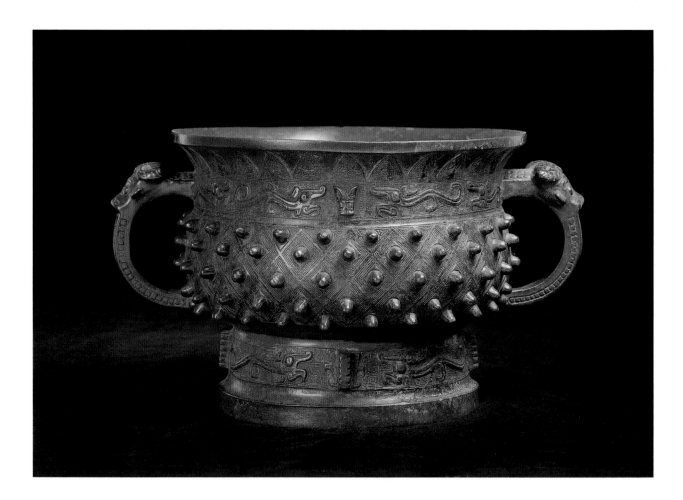

57
Ritual food vessel, the *'Teng hu' gui*, c.1100ʙᴄ
Western Zhou dynasty
Bronze, 23.8 x 32.4 cm

This important early ritual vessel is known as the 'Teng hu' *gui*. Its name comes from the inscription inside, which indicates that it was made by a man named Hu for his deceased ancestor in the feudal court of Teng, located in modern Shandong province.

The Chinese vessel known as a *gui* was used for offering food to the deceased. The decoration on the vessel is typical of the period; its handles feature large animal heads and there are bands of incised marks on the base and below the rim.

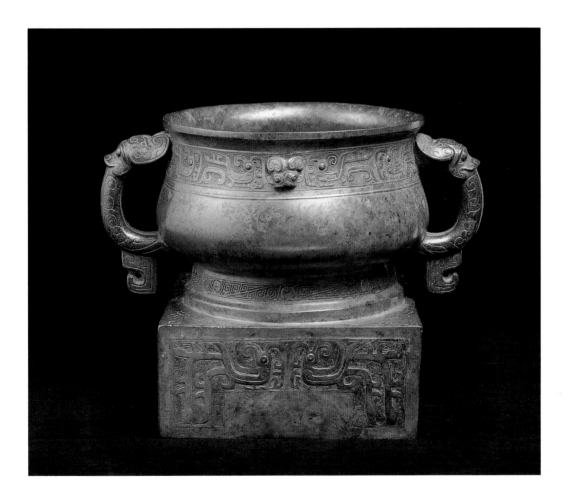

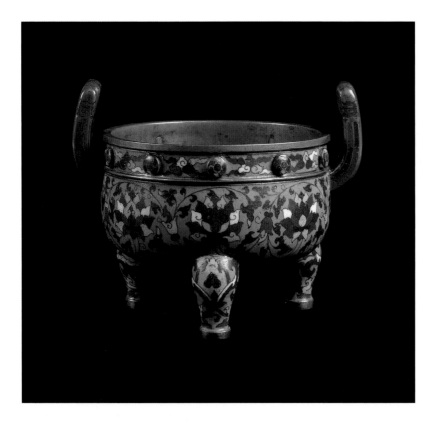

58
Incense burner, c.AD1400–50
Ming dynasty
Cloisonné enamel on gilt-bronze,
width 19 cm

This tripod is very similar in form
to earlier bronze ritual vessels. It is
made of brass and decorated with
'cloisonné' – a multi-step enamelling
process, which originated in China
and involves the application of silver
wire on the metal body to define the
coloured areas; the subsequent filling
of these areas with enamel (itself
made from boric acid, saltpetre,
alkaline and a pigment); firing;
polishing; and gilding.

This piece features an elaborate
lotus scroll, a form of decoration
developed in Chinese silverware and
ceramics from about AD700 onwards.
By this date, the original use of the
tripod as a food vessel had been
forgotten and it had become popular
as the central vessel in altar sets,
holding sand in which stood sticks
of incense.

opposite:
59
Stem cup, date unknown
Ming dynasty
Cloisonné enamel on gilt-bronze,
height 10 cm

The cloisonné decoration on this
delicate gilt-bronze stem cup
features six lotus flowers set amid
scrolling lotus leaves. The foot is
decorated with grapes on a rich
turquoise background.

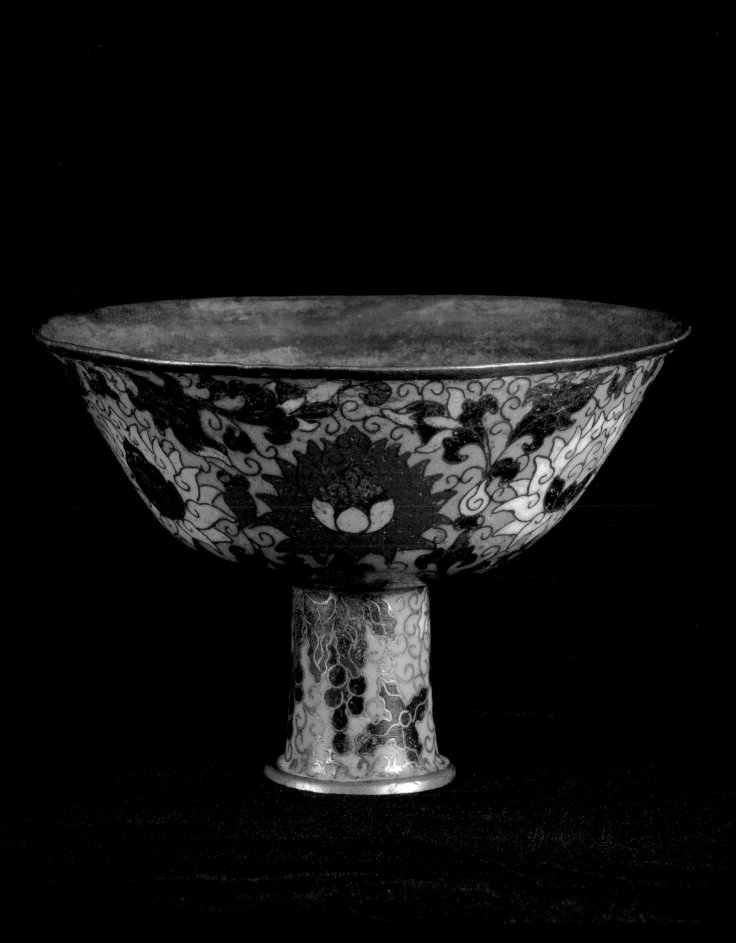

60

Ritual vessel or *fu*, *c.*600–500BC
Eastern Zhou dynasty, Spring and Autumn Period
Bronze, height 25 cm

A *fu* was a rectangular ritual vessel used for holding food, where the lid and body were usually of the same shape. This type of vessel was made in bronze from the Late Western Zhou period onwards and was possibly based on earlier bamboo examples.

This impressive piece is decorated with large loop handles cast with tubular-horned animal masks, set with tight curls and six small monster or *taotie* masks overhanging the rim of the cover. There are two incised six-character inscriptions on the interior of the lid and body; the first reads 'Da, son of the Ni family, owns this food container' and the second 'Xin, son of the Ni family, owns this food container'. The style of calligraphy helps date the vessel to around 600BC.

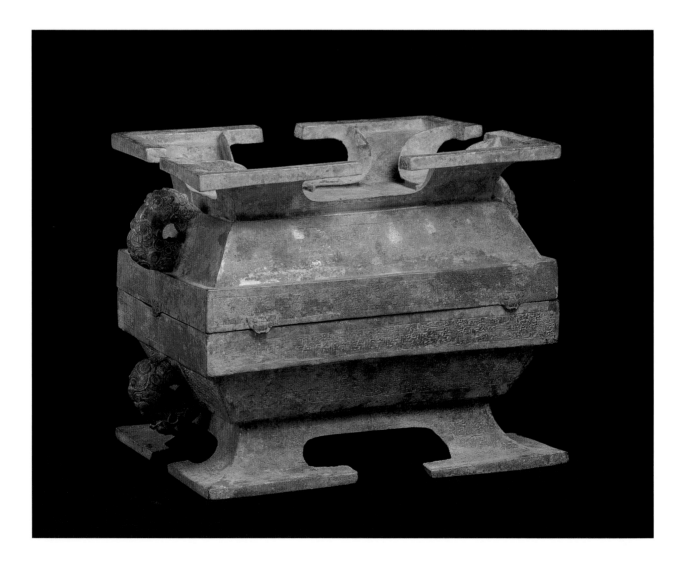

61
Ritual vessel or *ding, c.*1200BC
Late Shang dynasty
Bronze, height 24.5 cm

A *ding* was a ritual vessel for cooked food. This piece has the traditional decoration associated with the Late Shang dynasty, which includes stylised monster face masks, known as *taotie*. Such masks were common decorative motifs on bronzes of this period and their shape evolved during the Shang and Early Western Zhou periods. This vessel is also decorated with black incised infill and the remains of some malachite inlaid decoration. In addition, the sides have six vertical flanges that divide up the decoration into panels.

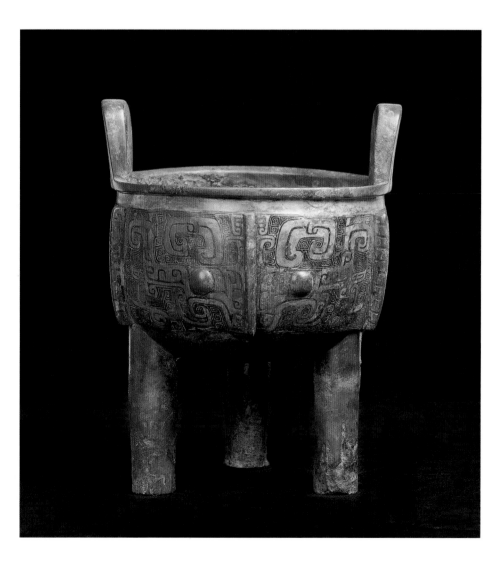

62
Wine vessel and cover or *zun*, *c.*200BC
Han dynasty
Bronze, height 29 cm

A *zun* was a ritual vessel for serving wine. This cylindrical bronze example stands on three legs and is decorated with bands of incising and 'feather-tip' design. The cover is in the form of a mountain, with incised creatures and wavy lines, and surmounted by a finial cast in the form of a phoenix.

This shape of vessel has also been found in pottery and ceramic forms from the region of Canton in southern China. This particular piece is dated to the Han dynasty, a period of centralised power and Cantonese conquest of neighbouring lands. At the same time, views of the afterlife evolved considerably, leading to a transformation in burial practices and to the construction of tombs specifically designed to represent the universe in which the dead were expected to live.

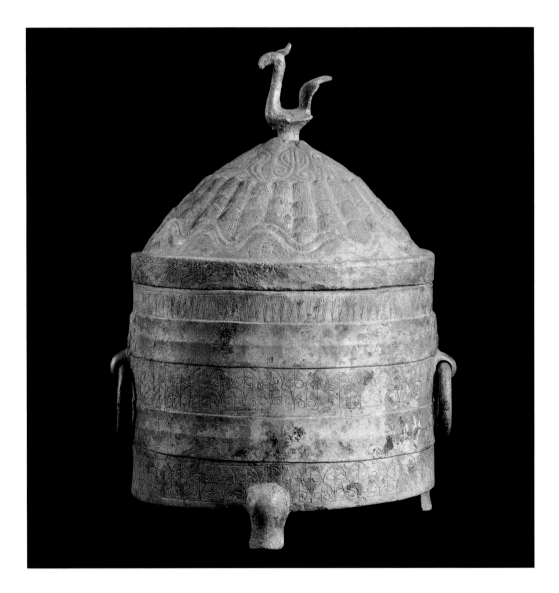

63
Ritual vessel or *dou*, *c*.400–300BC
Eastern Zhou dynasty, Warring States Period
Bronze, height 24 cm

A *dou* was a ritual vessel for offering food, in the shape
of a shallow cup raised on a high foot. Such vessels were
commonly made in ceramic and lacquer, but from the
Late Western Zhou period they were also made in
bronze. The decoration of this piece is characteristic of
the innovative and varied approach of craftsmen of the
Eastern Zhou. It is cast in low relief around the body,
the domed cover and the foot, with bands containing
horizontal registers of curled dragons framed by square
cells. The waist is encircled by a raised rope-twist band.

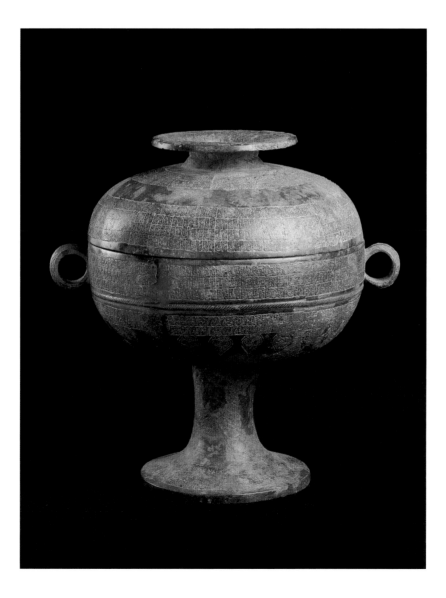

64

Tripod vessel or *li*, *c*.3000BC
Neolithic period
Pottery, height 30.7 cm

This is the oldest object in the Compton Verney collection
and dates from the Neolithic period in China – three
millennia BC. The great majority of Neolithic ceramics,
even the most finely made ones, were strictly functional.
They tended to be made using simple techniques, such
as building up coils of clay to make basins, jars, cooking
pots and large containers. Some excavated graves have
yielded masses of pieces, which indicates that the ceramic
industry was extensive; among the tombs have been
found some items that were exquisitely painted and far
from everyday.

This *li* is a large tripod vessel used for cooking food
and is decorated with applied pressed wave-twist elements
along the legs and the rim. The shapes that were intro-
duced into Neolithic pottery were adapted in bronze in
later dynasties.

65

Ritual wine vessel and cover or *guang, c.*1100BC
Shang dynasty
Bronze, length 20.3 cm

This form of wine vessel existed only from the Anyang period of the Shang dynasty to the middle of the Western Zhou dynasty. The shape of the vessel helped when pouring the wine and the cover sealed in warmth and kept out contaminants. These vessels are called 'zoomorphic' (shaped as an animal); they usually had the head of a tiger or a dragon forming the front of the cover. The cover on this bronze has the head of a bottle-horn dragon with sharp serrated teeth and a coiled tail.

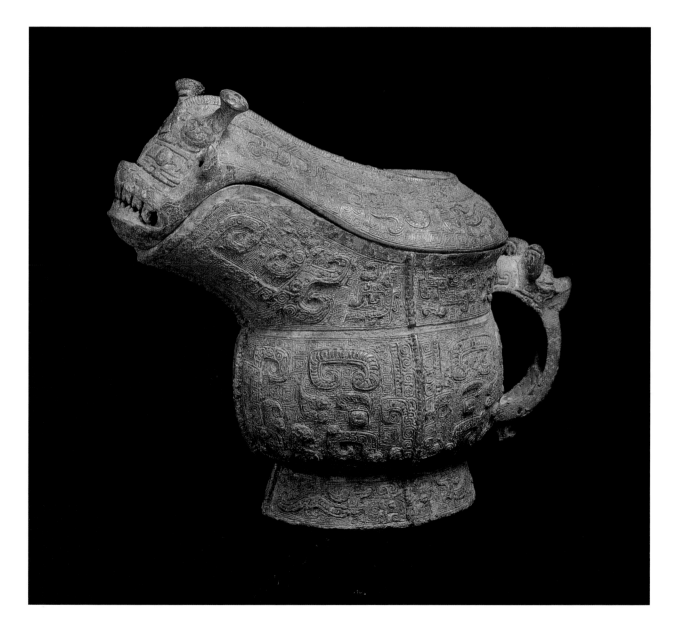

66

Wine vessel and cover or *fangjia*, date unknown
Late Shang dynasty
Bronze, height 30.7 cm

Fangjia are one of the rarest types of wine vessel from the Shang dynasty and only a few other examples can be seen around the world in museums and private collections. This *fangjia*, with a central motif of an owl's head on three of the four sides, appears in its design to be unique.

Birds of all kinds – and especially owls – were frequently used to decorate Chinese bronzes. Owls were considered to be omens of good fortune by the ancient Chinese and were particularly common during the Shang dynasty.

As with the other bronzes in Compton Verney's collection, this bronze was well preserved for thousands of years partly because it was buried in a tomb. When first made, it would have been used at banquets in temples, when food and wine were offered to ancestors. This *fangjia* may have been owned by a member of royalty or by a particularly high-ranking official, as it is in such tombs that the majority of previously discovered *fang*-shaped vessels have been found.

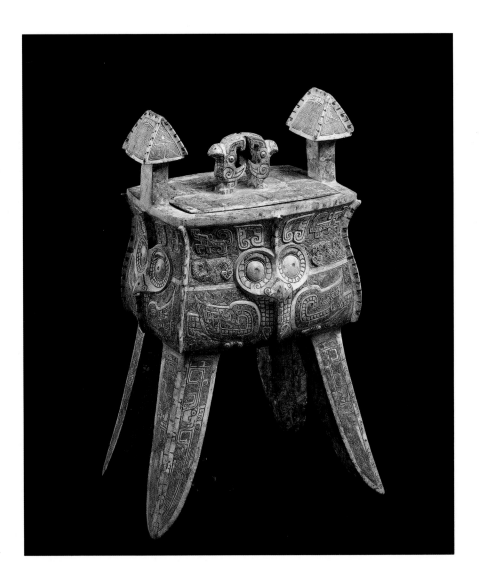

67
Ritual food vessel and cover or *dui*, date unknown
Eastern Zhou dynasty, Warring States Period
Bronze, height 24 cm

This unusual bronze is spherical and is made of two
symmetrical vessels. It can stand either way up and the
top can also stand up separately. This vessel is a grain
container called a *dui*, a shape that replaced early bronze
types such as the *gui* and *fu*. It has a sophisticated design
of interlocking scrolls and was originally decorated with
copper and malachite inlay.

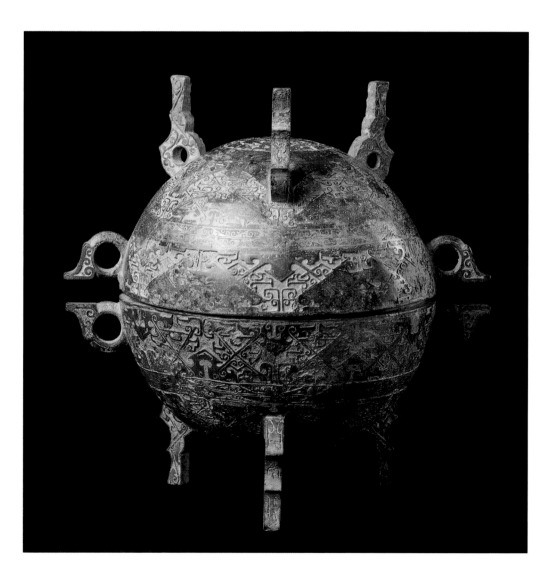

68
Large bell or *nao*, *c.*1100BC
Late Shang or Early Western Zhou dynasty
Bronze, height 61 cm

Large bells such as this example are typical of southern
China and were sometimes used in rituals in which
sacrifices were made to ancestors. The bell was designed
to produce two separate notes when struck with a mallet
– one from the centre of the rim and one at the corner.

 This bell is decorated with three rows of nippled
bosses known as *mei*. The rim is decorated with a cast
pattern derived from the monster-mask motif or *taotie*
and has a long inscription that was added later.

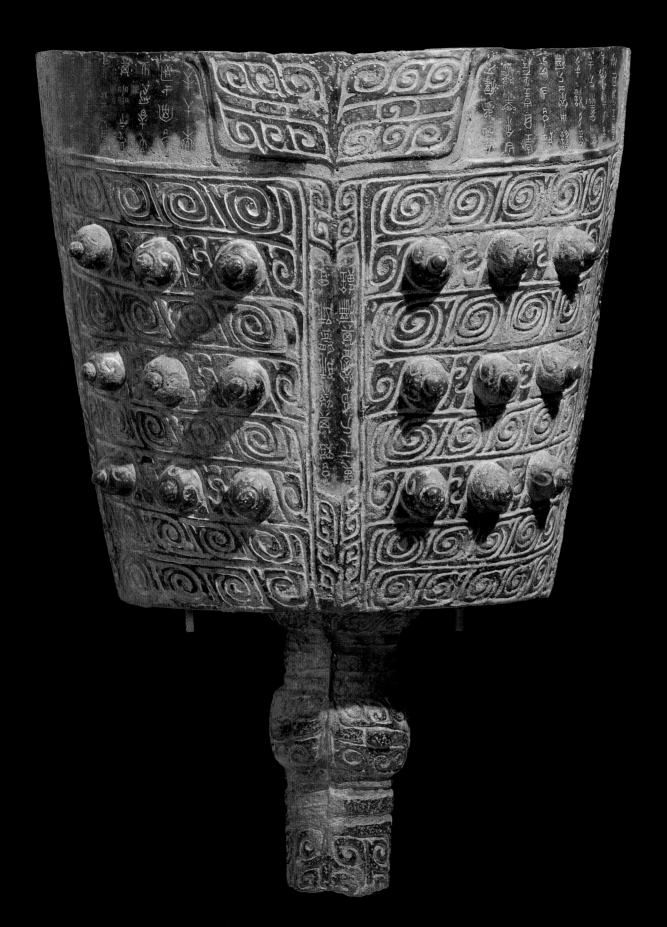

Folk Art

Folk Art
Emmanuel Cooper

Traditionally, the term 'Folk Art' was reserved for objects made in rural, pre-industrial societies where settled communities whittled, carved, sewed and thatched, fashioning objects that grew out of long-established craft traditions. Such objects may have had a use in and around the home, but their decorative elements took them out of the purely functional and practical and imbued them with special status. An apple corer cut from a sheep's thigh bone, for example, is perfectly functional, but when it is engraved with a zigzag pattern it is made special by the attention it has received. Folk Art was made by people who had no academic training as artists, but who made use of their innate abilities or the skills acquired as part of their trade or occupation.

Here, the term 'Folk Art' is used more widely to identify a body of work made within both rural and urban communities in pre-industrial and industrial society (c.1750 to the present day) by men and women of modest means mostly for their own pleasure and enjoyment as an expression of some inner creative urge. As is now recognised, there were no clear divisions between pre-industrial and industrial society, but many decades during which mechanical means of production were introduced, the transport infrastructure slowly developed and agricultural production methods intensified. As a result of these changes, Folk Art gradually found new forms and means of visual expression and communication.

Today, Folk Art is recognised as much by its characteristics as by the context within which it was produced, and it still continues to be produced, often in odd or unlikely forms. For example, in 2007 a newspaper carried a photograph of a house in Belfast that had been converted to an Elvis Presley shrine commemorating the death of the rock-and-roll entertainer. Adapting and interpreting commercially produced imagery, the householder had gone to great lengths to make statues of the singer. These were placed above the door, while stencilled patterns and slogans on the walls added to the overall decorative effect.[1]

Folk Art has always existed alongside fine or academic art. Traditionally, there was little influence or interaction between them. However, as Folk Art began to be produced within industrial society, interaction between the two traditions increased. Some fine artists adopted aspects of Folk Art as a 'style' in their work, while folk artists often reflected aspects of fine art. This was particularly evident in painting, where closer links were established. However, unlike in fine art, the question of originality has not been a primary concern for folk artists who have felt free to copy earlier forms as a mark of admiration and respect. One of the characteristics of the approach of folk artists is that they often added their own decorative elements to familiar forms. This might be by amending complex knitting patterns, introducing variations on sewn designs, freely interpreting traditional quilting patterns or in carving their own motifs on walking sticks.

Some observers have compared Folk Art to a flowing river that finds its own way and moves along at its own pace, contrasting this with high art, which is highly nurtured, cultivated and controlled – a canal in comparison with a river. In this sense, Folk Art conveys the authentic and cultural characteristics of a community as well as an individual or idiosyncratic artistic identity. Distinctions also need to be drawn between Folk Art and 'Popular Art', which is produced for the use of 'ordinary' people and includes such things as the

colourful wrappers on fireworks and sweets, printers' labels, and decorated cakes and bread forms.

Like the shrine to Elvis, rites of passage and festivals – religious and secular – were the focuses around which objects were made. In this respect, historically, Britain is relatively poor in Folk Art in comparison with many European countries due to the far-reaching effects of the Reformation. This introduced an aesthetic of purity and plainness, discouraging decorative work that was deemed to fall outside the simple and austere. Equally, the early onset of industrialisation saw the migration of people to towns and cities, so destroying many often long-established traditions in which Folk Art had a vibrant role. However, it is clear that not all such traditions faded out but were adapted to changed conditions. Knitting sheaths, for example, usually carved in wood and decorated with engraved patterns, began to be made in metal. Within industrial societies, the growth of trade unions became a new focus for Folk Art, whether with decorated banners or insignia.

The high level of individual involvement in making Folk Art encouraged great pride in the work and the sense of accomplishment it represented. While little documentary information survives, drawings and early photographs of trade processions and factory workers illustrate employees proudly holding objects they have made as evidence of their craft – a craft that pushed skills to the limit. These included full-sized swords that could be waved and top hats that could be worn. An illustration of a trade procession (Bristol Museum and Art Gallery) depicts glass-blowers holding up pots on the ends of poles, while shipbuilders hold miniature sailing ships. Other trades produced aprons decorated with the tools of their trade or, for pottery workers, miniature kilns that were carried full of smoking rags.

Although few, if any, of the creators of Folk Art were professionally trained as artists, much of the work was highly skilled. Artisan crafts such as pottery, basket-making, glass-blowing and blacksmithing all involved a thorough knowledge of material and process that formed the basis for more expressive work. Potters often decorated functional pots with designs of abstracted foliage or birds to make them special rather than more useful. Signwriters and coach painters, some of whom would have served an apprenticeship, sometimes used their skills to carry out paintings, such as portraiture, often in a naïve style that was a reinterpretation of high art.

Unlike high art, Folk Art was rarely produced as a commodity, its value having particular meaning and significance for the people who created it and to the communities within which it was made. When families pore over photographic albums knowing the individuals depicted and the situations shown, few images have captions for none are needed. Folk Art operates in much the same way. All of this presents a challenge in charting its history and development, or of adopting a formal academic approach.

Partly because of this lack of information, many Folk Art objects collected by museums have been categorised as 'curiosities' or 'bygones' with little information or documentation of how or when they were acquired, let alone who might have produced them. Rarely is the name of the maker recorded or the date or place of manufacture, which makes the task of establishing a chronological history virtually impossible. This is not only because of the absence of agreed facts but also because traditions and practices differed across the country.

An alternative approach is to try to place the objects in the social and economic settings within which they were made, such as home, leisure and work, rather than attempting to adopt academic definitions of painting, sculpture, craft or design. While such concepts are present, they bear little relationship to the way Folk Art was made or the purposes for which it was intended.

However, even broad terms such as home, work and leisure are not immediately applicable to pre-industrial societies where such areas were often one and the same. Daily life centred in and around the dwelling, while many communal activities revolved around religious or secular festivals. Working the land through agriculture or husbanding cattle or shepherding sheep were key activities. Tools had to be made for cutting and shearing and suitable furniture, such as benches, had to be built. Metal sieves, equipment for threshing, even wagons, were needed and all required skill to make. Some were made by workers, others by more specialist craftsmen, but there was likely to be significant crossover between them. With time on their hands when minding sheep, for example, shepherds carved love tokens in wood. Smocks worn to protect clothing from the physical handling of livestock, and made of stout cotton, carried individual patterns. They varied in quality from those intended for everyday wear to more elaborate ones reserved for use on special occasions. All were home-made and continued to be produced until the early twentieth century. The ones for special occasions invariably were more ornately decorated with intricate sewn patterns and smocking, evidence of the maker's ingenuity and skill.

Industrialisation brought new ways of working with workers travelling to their workplace. The urge to make and decorate remained but was adapted to different forms. Apprentices within manufacturing industries such as iron and steel, furniture manufacture and in mines became adept at handling materials and machines. Apprentice pieces, intended to show off skill and ingenuity, were usually miniature versions of manufactured objects. For their own satisfaction, workers often made complex models, whether of old-fashioned kitchen ranges or miniature steam engines, that worked beautifully. Within trades such as glass manufacture, which involved a variety of handworking skills, workers used glass left over at the end of the day to create their own objects, known as 'friggers' or 'end-of-days', to take home. At factories producing damask, weavers invented their own patterns to decorate lengths of cloth. Rites of passage served as creative focuses for expressive work. Brides were sent off in dresses decorated with the objects with which they worked.

As clearer separations developed between work and home, the family home came to be seen as the nest, the haven, a secure, private place in an often uncertain world. In the latter part of the nineteenth century, the home came to take on the significance we know today. Although modest in size, homes were made comfortable with pegged rugs, sewn quilts and patchwork and home-made items of furniture, while knitting and sewing provided items of clothing with the necessary skills passed down from generation to generation. As leisure time increased, so objects were

83 (see p.141)
Military Patchwork, c.1860

made that were more intricate and detailed. Elaborate quilts and patchwork, for example, became a significant part of married life with one often sewn in anticipation of the marriage bed. Designs tended to be reinterpretations of familiar motifs, such as overlapping circles (created by drawing round plates), half drops or crazy patterns.

Coverlets were part of the 'make do and mend' culture that made use of old or unwanted materials. Dresses, coats, shirts and suchlike were neatly cut up and the pieces reassembled to create colourful designs. These also related to the life of the maker. In certain parts of the country, sewing bees were held, partly as social gatherings but also to enable friends and family to work collectively on a coverlet. The making of patchwork was additionally a technique adopted by soldiers in the armed forces, often with great skill. A soldier's coverlet in the Compton Verney collection (83) brings together a design of almost heraldic significance, incorporating insignia and national flags of various regiments and countries. It was made from scraps of uniforms and was clearly intended to endure.

While women were mostly responsible for knitting, in ports sailors would often be seen handling the needles. Designs, such as Fair Isle, were traditional and intricate, intended to indicate the residence of the fisherman, but the knitter frequently added a personal modification to the design. Knitting methods and techniques differed across the country, with some using sheaths, others two, four or even circular needles. Knitters were adept and could improvise: when knitting a pair of gloves, for instance, experienced knitters were able to 'make it up as they went along'. Lacemaking and embroidery were also popular in presenting opportunities for individual expression. This craft was slow and meticulous but added finery to special clothes such as christening garments.

Carving wood was generally a more masculine occupation. In the early twentieth century, brightly painted whirligigs, often fashioned in the form of soldiers or sailors, were placed on the tops of posts in the garden or yard, their whirling arms blown round by the wind, indicating its strength and direction. The simple, abstracted forms combined technical understanding with artistic expression (74). The introduction of foot-operated fretwork saws opened the possibilities of making objects such as calendars, letter racks and toast racks, all carefully cut with patterns of abstracted foliage that might feature oak leaves and flowers.

In the latter part of the nineteenth century, painting began to be taken up by folk artists, with painters adopting the form from fine art. Houses were decorated inside and out with murals, although most painting was carried out on wood, paper, card or canvas. Many folk artists depicted what was familiar to them. For Cornish folk artist Alfred Wallis (1855–1942), this was the sea, ships and the landscape around St Ives, the town in which he lived (84). In addition to using their surroundings, artists often based their work on popular prints or magazine photographs, depicting topographical views, friends and family.

While the traditional concept of Folk Art seems to belong to another, less sophisticated time, the urge to create continues. Today, folk artists personalise objects as varied as cars, motorcycles, ghetto-blasters, radios, clothing and Doc Martens boots. The body, too, has become a focus for ornamentation, with piercings, tattoos, hair extensions and beards creating exotic and often complex works of art. At sports events, such as football or rugby matches, supporters are uninhibited in decorating their faces. In its broadest sense, Folk Art takes many forms, which today may centre on the individual as much as the community. Yet, however diverse, such work is part of visual expression and communication that has deep roots in society.

Note

1. *Guardian*, 16 August 2007

69

John S. Newton (1828–54)
Pottergate, Richmond, Yorkshire, 1847
Oil on canvas, 73.2 x 86.8 cm

Folk Art paintings frequently depicted topographical views, which were often commissioned by the local shopkeepers or businesses whose premises appeared in the work, as a form of advertisement. This painting of Richmond in Yorkshire shows the main street leading into town, Pottergate. On the left of the painting is Number 8,

Pottergate, a red-brick building with a sign over the door that says 'Newton, Painter, gilder, paper hanger'. The artist's father was also called John Newton and the artist, who was 19 when he painted this picture, included his father's premises in the composition. He added local colour in the shape of the foreground figures; one of these is Jackie Patterson, the cleaner of the local privies, who is seen on the left with two donkeys. The small man carrying a parcel is Harry Pickall, private postman to local landowner, the Marquis of Zetland.

70

George Smart (1775–1846)
Old Man and Donkey, 1833
Collage on paper, 37 x 31 cm

The amateur artist George Smart was a tailor in the village of Frant, near Tunbridge Wells in Kent, who made pictures and figures out of scraps of leftover cloth. He became very popular and his pictures were collected by Queen Victoria's (1819–1901) uncle, the Duke of Sussex (1773–1843).

Smart often included portraits of local figures in his work, such as this postman – known as 'Old Bright'. The portrait of the postman is made up of scraps of fabric pasted onto an engraving, which Smart has hand-coloured with watercolour. It is an accurate topographical view: 'Old Bright' is walking down Church Lane in Frant, towards the post office, which was opposite the building marked 'Smart's Repository'. Smart produced a number of different versions of this picture, which he sold to visitors in the popular spa resort of Tunbridge Wells.

71

Portrait of Daniel Lambert, c.1800
Oil on canvas, 87.5 x 75 cm

This is one of many portraits that were painted of Daniel Lambert (1770–1809), celebrated in the late Georgian era as 'the fattest man in Britain'. Leicester-born Lambert was the eldest son of the Earl of Stamford's huntsman and as a youth was a keen sportsman. However, his weight began to balloon uncontrollably and by the age of 23, in 1793, he weighed 32 stone (203 kg), making it likely that he suffered from a medical condition. He

succeeded his father as Keeper of the Leicester Bridewell prison, a post that he resigned in 1805 when he found that his position as the fattest man on record had led to a lucrative celebrity status.

Visiting London in 1806, he took lodgings in Piccadilly and 'received' paying visitors between 12 noon and 5pm. After this, he made a successful tour of the provinces, drawing large crowds in each town on his route. At his death in 1809, he was said to have weighed 52 stone (330 kg), and measured 5'11" in height (1.8 metres) and 9'4" (2.84 metres) around the waist.

72

Attributed to John Collier (1708–86)

The Dentist, c.1770

Oil on panel, 52 x 74 cm

The popular artist John Collier, an itinerant schoolmaster also known as 'Tim Bobbin', painted a number of pictures of popular dentistry relating to engravings for his *Human Passions Delineated*, a book of verse and cartoons satirising English professions, which was published in 1773. In most of these paintings, however, the 'dentist' holds his left leg against the patient's chin, not the right leg as in this painting. The engraved version of the scene is entitled 'Laughter and Experiment', with the following verse as explanation:

A packthread strong he tied in haste
On tooth that sore did wring:
He pull'd, the patient follow'd fast,
Like Towzer in a string.

He miss'd at first, but try'd again,
Then clapp'd his foot o'th chin;
He pull'd – the patient roared with pain,
And hideously did grin.

73

The Cock Fight, c.1850

Oil on canvas, 76 x 88.5 cm

Many of the scenes represented in Folk Art paintings such as this take place at moments of great dramatic tension. The cock fight depicted here is just beginning: the two birds in the foreground of the canvas are about to fight, encouraged by the two young boys; the birds' owners, wearing top hats, eye each other and hold in their hands the hoods that they have just removed from the birds' heads. The fight takes place in an indoor arena, watched – and bet on – by a large number of onlookers. At the top right of the canvas, a policeman (a 'Peeler') carrying a truncheon bursts through the door. Cock fights became illegal in 1849; the officer is presumably arriving to enforce the law and arrest the perpetrators.

74

*Pony and Trap Whirligig, c.*1900
Wood with metal parts, 51.8 x 65.5 x 13.2 cm

Whirligigs were a hand-carved and painted type of weathervane that could be found in the town or the country. The term 'whirligig' derives from 'gig', meaning a whipping top, and can be used to describe any spinning or whirling toy. Whirligigs were generally home-made from cheap materials and featured articulated elements that moved with the wind. They were very vulnerable to the elements and therefore few survived the damp English weather.

This whirligig is made of painted wood and metal, and comprises two figures sitting in a trap drawn by a horse, mounted with a propeller. Although probably home-made, it is a sophisticated model. The figures both wear hats and one holds the reins of the horse as it approaches a tree. When the propeller turns, the horse's legs move as if trotting. There is a small hammer located between the feet of the driver, which clatters to simulate the noise of the horse's hooves.

75
*Seated Dog Weathervane, c.*1880
Iron, 62 x 66 x 5cm

The weather was an important factor for the farmer and the sailor, making the weathervane a significant instrument in pre-technological society. Rural and sea-faring communities needed to be aware of the wind direction to protect their crops and ships. The weather-vane – its name deriving from the Old English *fana*, meaning flag or banner – was also an expression of the blacksmith's art. Weathervanes could take many different forms including cocks (which carried a religious significance); other birds, such as swans or doves; fish (a good shape to catch the wind); and, inevitably, ships. They were often made of beaten iron, in this case painted white and in the unusual shape of a seated terrier.

76

J. Miles (dates unknown)
A Surprising Incident, c.1811
Oil on canvas, 54.1 x 67 cm

This painting portrays an 'incident' at a farm at Far-mington near Northleach, Gloucestershire, in July 1811. A butcher had been called to slaughter an old cart horse, which managed to escape. The inscription underneath reads:

An Instance Never Known Before.
In July 1811: A Butcher went to the Seat of Thos. Willan Esqr. at Farmington near Northleach Gloucestershire. To Kill an Old Cart Horse. After he had struck the Horse, the man employed to hold it dropt [sic] the halter. The Horse immediately ran at the Butcher, who took to his heels, and after several turns in the field, they entered the rick-yard. The Butcher being an Old man and quite exhausted, fell between the ricks. The Horse caught at him (but luckily missed) and fell to upon a mare. In a few minutes the man of Blood, assisted by fear crept softly away not to disturb his persuer [sic] till it was quite dead.
Painted by J. Miles Northleach.

77

Accident on the Road to Inverness, c.1825
Oil on canvas, 78.5 x 57 cm

This dramatic scene of a carriage accident probably records an actual event that took place on the road to Inverness in the mid-1820s. The carriages are painted in detail, showing the accident as it is happening. One smaller vehicle has overturned in the centre of the road and the horses in the carriage behind are trying to break free and unseat the coachmen. The topography is painted in sufficient detail to identify the stretch of road, which was probably on what is now the A96. Castle Stuart is shown in the background on the left, indicating that Inverness is to the left of the picture. To the right is Nairn and in the distance are ships in the Moray Firth travelling to Inverness.

78

Model of a Butcher's Shop, c.1900
Wood and paint, 37 x 61.5 x 12 cm

This painted wooden model was possibly made by the butcher himself. This kind of model would have been placed in the shop window at night after the meat had been sold or cleared away, to display the various cuts and joints of meat available during the day. The figures of the butcher and his boy can be seen standing outside the shop, surrounded by different joints of meat, which hang in rows. On the right, a large piece of meat sits on a butcher's block, ready for cutting. Two trees made from grasses stand on either side of the building.

79

Model of a Potter's Workshop, c.1900
Wood and metal, 32 x 35 x 24.7 cm

This model was probably made by someone who was actually a potter. Two men, the potter and his assistant, are in the workshop and they both move when operated by a key from the reverse. The man on the right is turning the flywheel that drives the potter's wheel, and he raises his left arm intermittently to mop his brow with a rag. The potter, seated at his wheel, is drawing a pot and, when the wheel turns, his arms move up and down to shape the revolving form. At his side is a pile of clay and on the floor is a tray of unfired pottery ready for the kiln. Behind the two men are shelves of white-painted zinc crockery.

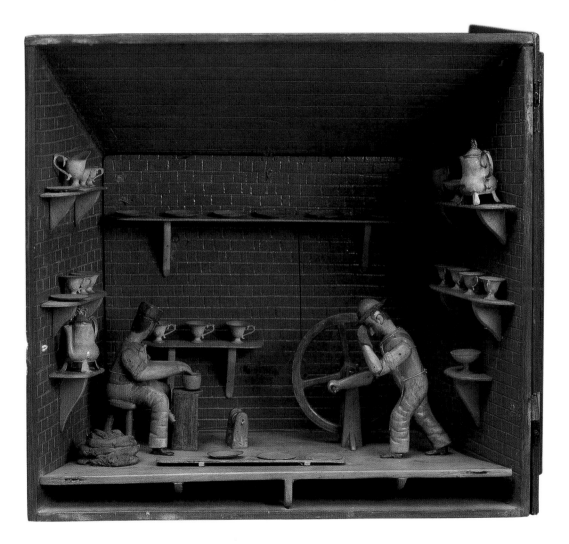

80
Admiral Lord Exmouth, c.1815
Ink, watercolour and gouache on paper, 66 x 54.2 cm

Sir Edward Pellew (1757–1833), subsequently Admiral
Lord Exmouth, was a distinguished and highly successful
naval officer. Having joined the navy at the age of 13,
he was responsible for the capture of the first enemy
warship (together with its naval codes) following revo-
lutionary France's declaration of war against Britain in
1793, for which action he was knighted by King George III
(1738–1820). In 1796, he was commanding the Western
Frigate Squadron from the HMS *Indefatigable* when the
latter captured the French frigate *La Virginie* (see 81).
Shortly before this, his bravery in swimming out to rescue
a wrecked troopship earned him a baronetcy.

Pellew was promoted to Rear Admiral in 1804,
appointed Commander-in-Chief of the Mediterranean
Fleet in 1811, and created Baron Exmouth of Canonteign
in Devon in 1814. Active at sea until 1820, Exmouth
continued to be showered with honours until his death
at Teignmouth in 1833.

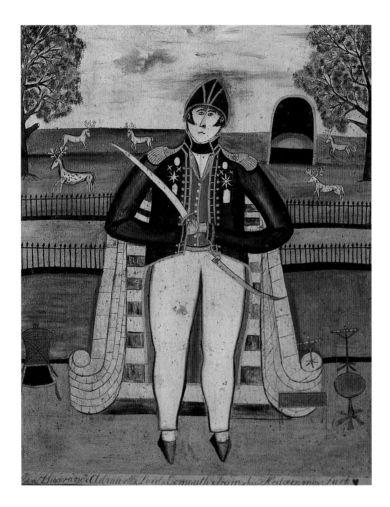

81

*The Indefatigable, c.*1800
Oil on canvas, 56.6 x 76 cm

Many items of Folk Art were produced by sailors who were whiling away their time at sea; therefore portraits of individual ships, such as this one, were not uncommon. This particular work shows the frigate HMS *Indefatigable*, protected by *Fame* (to the left) and *Hope* (to the right), engaging a French warship in 1796. The painting has a caption ringed in red at the top right, which reads:

> His Majesty's ship
> Indefatigable of 40 guns
> Sir Edw. Pellew engages and takes

La Verginia a French Frigate of 44 guns on the 22nd April 1796 off the coast of France Neptune and Amphritrite god and goddess of the Seas Riding Triumphant

The caption painted below reads *'Britannia rules the Waves'*.

Launched in 1784 but not commissioned until 1794, HMS *Indefatigable* had a very distinguished career. On 22 April 1796, while Britain was at war with France, she captured the French 44-gun frigate *La Virginie* off the Lizard (and not, as the painting alleges, 'off the coast of France') after a 15-hour chase. By October that year she had captured three more French ships.

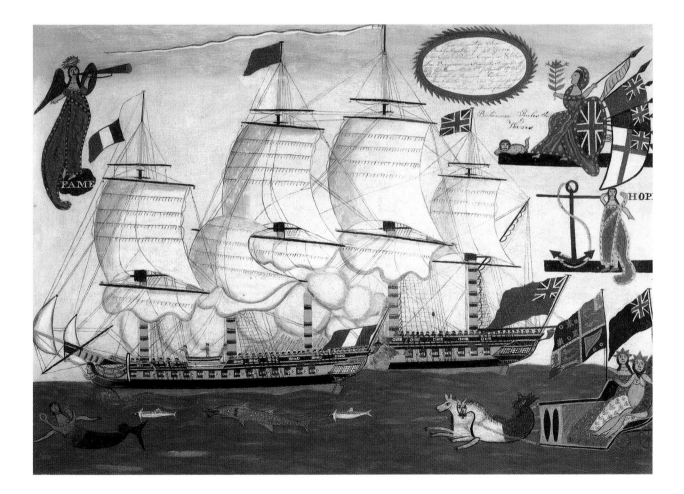

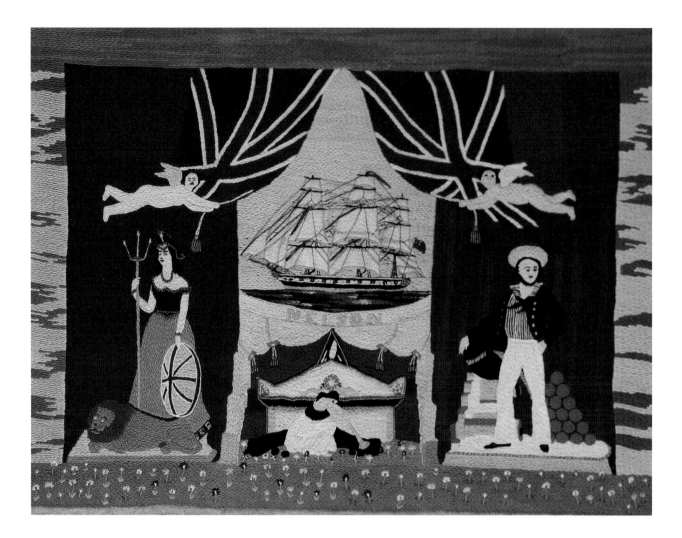

82

Nelson, c.1850

Wool and canvas, 55.8 x 77.8 cm

Rear Admiral Lord Nelson (1758–1805) was perhaps the greatest hero of the British navy. This colourful stitched wool picture was made many decades after his death at the Battle of Trafalgar and testifies to the enduring nature of his posthumous reputation. It bears Nelson's name across the centre, depicts his famous flagship at Trafalgar, HMS *Victory*, and his sarcophagus in the crypt of St Paul's Cathedral in London. To either side of the central scene stand Britannia, holding the shield and trident with a lion at her feet, and a sailor with a pile of cannonballs.

This carefully executed woolwork picture, with applied gold beading, was neatly stitched onto ship's canvas. It is of a type that was exclusively made by the British navy and reflects the pride that Victorian sailors felt both in their ships and in the British seafaring tradition.

83

Military Patchwork, c.1860
Patchwork, 254.5 x 209.3 cm

This regimental patchwork was
made for the 98th Regiment,
indicated by the XCVIII inscribed on
the Union flag in the centre and by
the regiment's colours. In 1881, the
98th was amalgamated with the
64th Regiment to form The Prince
of Wales's North Staffordshire
Regiment. The patchwork is made
with various scraps of military
material, possibly taken from old
uniforms. The initials 'V.R.' (Victoria
Regina) and the crown honour the
reigning monarch. The two flags are
the regimental colours, below which
are stitched two crossed rifles, a
badge that was awarded to the Best
Shot in the regiment.

The patchwork decoration dates
the piece to after 1854 – the use of
the 'Punjab' honour on the right-
hand colour, awarded for services
in the Punjab in 1848–49, was
authorised from that date – and
before 1876, since after this date the
98th had the title 'Prince of Wales's'
added to all the regimental colours.

84

Alfred Wallis (1855–1942)

*Schooner Approaching Harbour, c.*1930

Oil on metal, 32.1 x 41.2 cm

Alfred Wallis was an untrained, Plymouth-born artist who, from the age of 35, worked as a fisherman and rag-and-bone man in the Cornish port of St Ives. He began painting only after the death of his wife in 1922, using pieces of found debris such as boxes, jugs or jars, and he favoured maritime subjects. This painting of a schooner with red sails, approaching a harbour with a lighthouse, is painted on a tin tray.

In 1928, Wallis was discovered by two artists of the St Ives artists' colony, Christopher Wood (1901–30) and Ben Nicholson (1894–1982), who were interested in 'primitive' art. Thereafter, his works sold widely to contemporary artists and critics and were often exhibited. Nevertheless, Wallis died relatively poor in a Cornish workhouse.

85

Staffordshire Factory

Two Boxers, c.1815

Earthenware, each 22 x 11.5 cm

This pair of painted figures was probably made in a Staffordshire factory to commemorate the famous fight between Thomas Cribb and Thomas Molineaux, which took place on 28 September 1811 in a field in Wymondham, Norfolk. Boxing was an extremely popular sport during this period and significant amounts of money changed hands during betting. This match – only the second time that these two famous boxers had met – went on for 11 rounds. Cribb was ultimately the victor, leaving Molineaux with a broken jaw. Their epic fight was also commemorated in a number of engravings, and Cribb's name by a London pub.

Enid Marx
Steven Parissien

Enid Marx (1902–98) (fig.1) was one of the brightest design stars to emerge from the Design School of London's Royal College of Art (RCA) during the inter-war years. Her generation – later described by artist Paul Nash (1889–1946) as 'an outbreak of talent' – included Eric Ravilious (1903–42) and Edward Bawden (1903–89). Marx's artistic talents were prodigious: she excelled as a textile designer, an author and illustrator of children's books, a book designer, a printmaker and a painter.

Born in London, Marx – a distant cousin of Karl Marx (1818–83) (a fact that she was delighted to relate) – was educated at the famous girls' public school of Roedean, near Brighton in Sussex. Here her evident enthusiasm for drawing was encouraged by the school's enlightened Head of Art, Dorothy Martin, who let her young pupils draw from nude models. 'Roedean practically let me do drawing full-time in my last year', Marx later noted.[1]

Having arrived at the Central School of Arts and Crafts in 1921, the following year Marx transferred to the RCA, where she began by immersing herself in textile production. While she learned much there, she also proved an unorthodox student: she refused to produce what she termed 'the washed-out William Morris stuff' that the RCA tutors seemed to want, and was as a result banned from Sir Frank Short's (1857–1945) wood-engraving class (although after hours Ravilious taught her what she had missed).

Ultimately, Marx's championing of abstract patterning meant that she failed to gain a diploma at the RCA. However, by 1926 she had set up her own studio in Hampstead. Her designs, usually abstract and geometric, soon became extremely fashionable and sought-after; her customers included celebrities Gerald du Maurier (1873–1934) and Gertrude Lawrence (1898–1952). Publishers also recognised that Marx's designs would work well on book jackets. (Most appropriately, the first of Marx's book covers, designed in 1929, was for a monograph on the engraver Albrecht Dürer (1471–1528).) Simultaneously, Marx was introduced by Nash to the Curwen Press, with whom she collaborated on their celebrated book of sample patterned papers (published with an introduction by Nash himself) of 1928.

In the late 1930s, Marx and her friend, the historian Margaret Lambert (1906–95), teamed up for their first folk art project: collecting print ephemera, scrapbooks, valentines, paper peepshows, children's books and toys for a book entitled *When Victoria began to Reign*, which was published by Faber in 1937. That same year she was invited by the legendary Frank Pick (1878–1941) of London Transport (LT) to design a seating moquette for Pick's London Underground trains. This commission was the work of which Marx was most proud. As she wrote later:

> The project was great fun because there was a very strict brief. The seating needed to look fresh at all times, even after bricklayers had sat on it, so there was a camouflage problem. The design, therefore, had to be bold but, because it was for a moving vehicle, should not be dazzling to passengers. In order to achieve the right effect strong contrasting tones had to be used, combined with changes of texture, from cut to uncut moquette. The scale of the repeat was governed by the economy of cutting up upholstery for seats of divergent sizes.[2]

Fig.1
Enid Marx in her studio with one of her cats, *c.*1950

The results are the strong and timeless geometric designs that are famous around the world, and which are still in use today.

Twenty years later, Pick's more pedestrian successors re-hired Marx to design posters for LT. In the meantime, however, Marx had had a very busy war. In 1944, she became the first woman to be appointed a Royal Designer for Industry. Her skills as a watercolourist were harnessed when the Pilgrim Trust commissioned a series of watercolours from her, recording notable British buildings potentially under threat from German bombing. (In the event, the Trust's well-intentioned scheme – a variant of the National Monument Record's ambitious photographic campaign – became more of a series of typically English views than a record of bombing targets.) She was also invited by the furniture designer Gordon Russell (1892–1980) to become a member of the Board of Trade Utility Furniture team. Cheap and cheerful utility furniture was designed to be made in large quantities for homes that had suffered bomb damage; Marx's task was to create as great a variety of furnishing fabrics as possible from the very limited wartime supply of yarns and range of colours. At the same time, she ventured into writing and illustrating her own children's books, producing a series of small format publications, which included the celebrated title *Bulgy the Barrage Balloon* (London, 1941).

In the aftermath of World War II, Marx became increasingly fascinated by local craft traditions. She envied the contemporary interest in America and Scandinavia in what she termed 'Popular Art', which we now generally label 'Folk Art'. 'The innocent eye is disappearing in England', she bemoaned; 'As the

countryside becomes more urbanised … the country craftsmen are dying out and with them the individuality in design and decoration that gave life to the old popular art.'[3] Marx's scholarly volume on *English Popular and Traditional Art* of 1946 was transformed, with the help of her partner Margaret Lambert, into a more accessible form – published as *English Popular Art* – for the Festival of Britain in 1951. (A new edition of this book was published in 1989 by Merlin Press.)

Marx insisted that Popular Art should be about 'fantasy and humour', and should feature 'lush and colourful exuberance'.[4] These qualities abounded in

her own work, too; possibly her most famous production, the linocut letters of *Marco's Animal Alphabet* (92) – finally completed in 1979 and published together by the Incline Press in 2000, after her death – are consistently witty, engaging and playful.

Queen Elizabeth II's (b.1926) coronation in 1953 gave Marx the chance to explore yet another design medium: postage stamps. It was a commission that she relished:

> One of my greatest pleasures has been to work on stamps. The design is a sort of puzzle. Into this tiny national visiting card has to be fitted the Sovereign's head, the value and the given subject, commemorative or otherwise. For the Coronation definitives the four flower emblems of the kingdom had to be exactly the same size, in order that there shouldn't be any 'feeling'.[5]

More than 20 years later, in 1976, she designed a set of beautiful Christmas stamps based on the *Opus Anglicanum* embroideries.

Throughout the 1950s and 1960s, commissions continued to flood in for woodcuts, engravings and linocuts, packaging, calendars for Shell Oil, London Transport posters, greetings cards, book jackets and laminates. At the age of 63, when most people are considering retirement, Enid Marx became Head of Department of Dress, Textiles and Ceramics at Croydon College of Art in 1965. She stayed for five years and then left to pursue her own work.

During the 1970s, Marx successfully battled to save the Agricultural Hall in Islington (now the Business Design Centre) from demolition. Less successful was her campaign to establish a national museum for English folk art. Thankfully, though, much of her own collection and work is preserved today at Compton Verney (fig.2). (In 1998, Marx loaned items from her collection to be displayed alongside the Folk Art collection at Compton Verney and subsequently left much of her collection to the gallery in her will.)

Enid Marx's own approach to design and art was visually omnivorous, aiming to create a sense of the possibilities inherent in mass-production and an appreciation of the visual world. Throughout her life, Marx was always a voracious collector. She amassed French poetry books covered in pattern papers; children's books and toy theatre sheets; cigarette cards and inn signs; ceramics, corn dollies and gingerbread moulds. All of these can be found at Compton Verney. Marx's work won the admiration of critics and fellow designers alike. As architectural and design historian Alan Powers (b.1955) has observed:

> Enid was a brilliant pattern-maker with an eye for crisp design, a natural feel for and understanding of the importance of scale and a tremendous knowledge of many different printing techniques … She used simple units spaced in such a way that the patterns leapt to life on the cloth. The method of printing was very laborious and it is a great sadness to know that, because of that, we are unlikely to see the fabrics produced again in sufficient quantities for them to be widely appreciated.[6]

Notes

1.–6. All quotations are taken from the obituary of Enid Marx by Fay Sweet, *The Independent*, 19 May 1998

86

Maker unknown (Mexico)
*Animal Model, c.*1950
Papier mâché and fabric, 74 x 38 x 27 cm

This extraordinary imaginary winged creature, bought in Mexico and made out of papier mâché, has a dragon's head, painted goat horns, wings, a tail and cloven feet. It has a green shoelace tied around the middle, which may have been used for hanging.

It is typical of the type of figure produced popularly in Mexico using papier mâché, a cheap material involving strips of paper glued together and moulded to build up a figure. For Enid Marx, it was the type of object that she loved to collect and display in her crowded home, and which inspired her designs, since it demonstrated the creativity of the untrained mind.

opposite:

87

*Fantastic Animal Head, c.*1950
Wood and leather, 23 x 33 x 23 cm

This colourful wooden head of an imaginary fantasy bird is typical of the sort of popular and cheaply-produced object that caught Enid Marx's eye when she was looking for inspirations for her designs. The head has a gaping green bird's beak, tiger stripes on the plumage and red-ringed eyes. It has a hole on either side and a leather strap that may have been used for hanging.

88
Carved Figurehead, c.1850
Wood, 124 x 54 x 46 cm

Figureheads were one of the most characteristic expressions of Popular Art, particularly for a seafaring nation like Britain. The origins of the figurehead lie in prehistoric times; the decoration of vessels was common among ancient civilisations and often held magical or religious significance. The figurehead as we would recognise it today emerged in Tudor (1484–1603) times, and its form evolved in response to the design of the ships that they adorned, as well as to prevailing tastes in architecture and the fine arts.

In the early 1800s, the Admiralty imposed greater restrictions on the use of figureheads on naval vessels, but they continued to flourish in the commercial sector until the gradual introduction of steam-powered steel ships. This figure, with its bold and colourful Turkish costume, reflects British trading interests in the Near and Far East.

89
Maker unknown (British)
Pair of Doorstops, c.1850
Cast iron, 32 x 24 x 9.5 cm

This pair of cast-iron doorstops of Punch and Judy was hand-painted by Enid Marx after she bought them. Mr Punch is sitting on a pile of books, holding a pen and paper in one hand and tapping his nose with the other. He wears his typical flamboyant costume, with his lugubrious dog, wearing a hat, beside him. Judy sits on a box, holding their baby up to her face.

Mr Punch was a familiar character in folklore and popular culture, dating back to the *Commedia dell'Arte* troupes of actors in medieval Italy. The Italian storybook figure of Pulcinella was transformed in England into 'Puncinello' or 'Mr Punch'. He was later joined by a wife, Judy (originally known as Joan), and by 1700 the Punch and Judy show had become an English tradition.

90

Wedgwood factory, Stoke-on-Trent
Commemorative Mug, 1936
Ceramic, height 10.4 cm

This commemorative mug was produced in the Wedgwood porcelain factory at Burslem, Stoke-on-Trent. Wedgwood employed a number of famous designers in the modern era; one of the most celebrated was Marx's friend Eric Ravilious (1903–42), who designed this mug for the coronation of King Edward VIII (1894–1972) in 1936 – an event which, owing to the king's abdication after only 11 months on the throne in order to marry the American divorcée, Wallis Simpson (1896–1986), never took place.

Ravilious became one of the most important designers in the post-war period. He trained at the Slade School of Art and became a close friend of Enid Marx, herself also a graphic designer, who owned this mug. The mug shows the lion and unicorn supporters of the royal coat-of-arms, together with the initials 'ER'.

91

G.L. Ashworth factory, Hanley, Staffs

Bargeware Teapot, 1891

'Ironstone' stoneware, height 25.5 cm

The Mason family traded as potters at Lane Delph and Fenton in Stoke-on-Trent from *c*.1800 to 1854, specialising in a robust, everyday ware that they patented in 1813 as 'Patent Ironstone China'. Their factory, patterns and recipes passed to the firm of G.L. Ashworth and Bros in nearby Hanley in 1861; Ashworth's, however, continued to use the Mason name and ironstone moulds – so much so that in 1968 the company renamed itself 'Mason's Ironstone China Ltd'.

This tough ironstone product is of a type of china often known as bargeware due to its popularity among canal boatmen. Cups and saucers made of the same ware were so heavy that they were often used as domestic missiles, earning them the title of 'clout cups'. This over-sized teapot, with its rich dark brown glaze, is decorated with relief ornament of flowers and birds. In common with many bargeware teapots, this piece features a miniature teapot finial on the lid. The plaque on the side reads, 'A present from Mother to C O Lewsbury, 1891'.

92

Enid Marx (1902–98)
Linocut of the letter 'R', c.1970
Linocut on paper, 17.5 x 24.5 cm

Having already made a name for herself as a leading illustrator of books for children, Enid Marx designed an entire alphabet of different animals, which she completed in 1979 and which was finally published in 2000 as *Marco's Animal Alphabet*.

This bold and distinctive rhinoceros, intended to illustrate the letter 'R', is a linocut: made by taking a piece of linoleum, carving it out and inking it up to produce a print. It reflects the simplicity of her invention and sensitively depicts the form of the massive wrinkled rhino and its shadow.

93
Enid Marx (1902–98)
Tiger, Tiger, 1958
Linocut and watercolour, 71 x 10.5 cm

This five-colour, oval linocut by Enid Marx of a cat in a garden at night bears the label 'Tiger, Tiger' on the reverse, in reference to the celebrated poem, *The Tyger* (1794), by William Blake (1757–1827). The image originated as a design for a large embroidery, which was later produced by a group of Marx's embroidery students in Croydon.

Marx was a great cat-lover and her Siamese cats generally accompanied her in her studio when she worked.

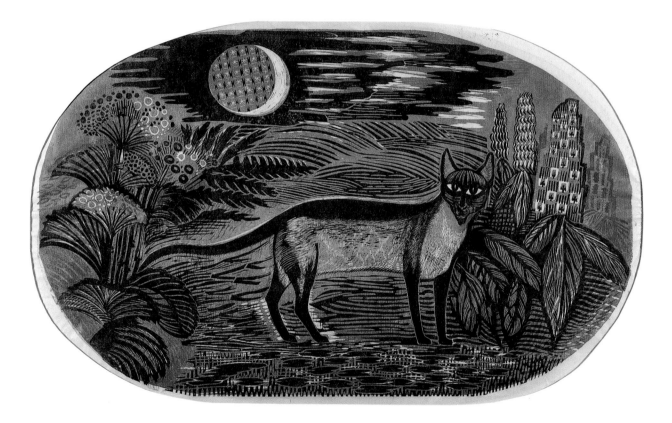

94

Thomas Stevens (1828–88)

The Present Time (A Railway Train), c.1870

Ribbon, silk and card, 16.1 x 25.4 cm

This picture, showing the early steam locomotive *Lord Howe* with two closed carriages, was woven by Thomas Stevens of Coventry. It is an excellent example of the Victorian fad for mechanically woven ribbon pictures.

Ribbon-weaving in narrow widths on a jacquard loom (operated by pre-punched cards) was a speciality of the city of Coventry, which had been making ribbons for over two centuries. By 1850, though, the fashion for ribbons was declining and the Coventry ribbon industry began to market a new product: pictures woven in ribbon. Thomas Stevens's firm produced the greatest number and variety; as a result, such ribbon pictures became known as 'stevengraphs'. The subject matter for such pictures was frequently taken from popular prints.

95

Maker unknown (British)

Canalware stool, *c.*1880

Pine, 35.5 x 76 x 26 cm

This long stool, in the shape of a bench, was made for a canal barge. It is a simple piece of furniture and reflects the friendship that Marx developed with those artists who produced objects for canal boats. Enid Marx and Margaret Lambert recorded their interest in English canal barges in their book, *English Popular Art*, of 1951. For them, barge decoration was painted in a free style that reflected a truly working-class craft tradition.

The stool is a colourful piece, decorated on the top with a romantic scene of a castle, with a bridge in the foreground and a lake and mountains in the background. The trestle-end supports are decorated with floral panels and the sides have colourful lozenge shapes of red, green, yellow, orange and black.

96

Maker unknown (English)
*Wall-mounted vases, c.*1890
Pottery, each 23.5 x 17.2 x 6 cm

These simple, decorative wall-mounted vases are in the
shape of a cornucopia, or 'horn of plenty', a symbol used
since classical times to depict peace, plenty and prosperity.
They are decorated with a delicate green glaze and a
moulded oval ornamental tablet depicting a female figure
(also holding a cornucopia) surrounded by acanthus
leaves and scrolls. Enid Marx bought the vases on one
of her many visits to antique shops and the cornucopia
motif proved an inspiration for her design work, featuring
in a pair of curtains now also in the Compton Verney
collection (see fig.2, p.149).